COLOR.

PANTONE® Guide to
Communicating with

PANTONE® GUIDE TO COMMUNICATING WITH COLOR
By Leatrice Eiseman

Copyright © 2000 by Grafix Press, Ltd.

Published by HOW Books, a division of F+W Publications. 4700 E. Galbraith Rd., Cincinnati, Ohio, 45236. For more fine books from F+W Publications, visit www.fwpublications.com.

Distributed in Canada by Fraser Direct, 100 Armstrong Avenue, George-town, Ontario, Canada L7G 5S4, Tel: (905) 877-4411. Distributed in the U.K. and Europe by David & Charles, Brunel House, Newton Abbot, Devon, TQ12 4PU, England, Tel: (+44) 1626 323200, Fax: (+44) 1626 323319, E-mail: postmaster@davidandcharles.co.uk. Distributed in Australia by Capricorn Link, P.O. Box 704, Windsor, NSW 2756 Australia, Tel: (02) 4577-3555.

Printed in the USA.

ISBN: 0-9666383-2-8

12 11 10 09 08 13 12 11 10 9

Art Director: Stephen Bridges
Designers: Stephen Bridges, Laura Herrmann
Picture Researchers: Stephen Bridges, Laura Herrmann, Joan Herrmann
Production Assistants: Joan Herrmann, Kathy Feerick
Front Cover Photographs by Don Paulson
Staff Photographer: Don Paulson, TEL 360-830-2212
 Web Site www2.tscnet.com/~dpphoto
Pantone Advisors: Michael Garin, Senior Vice President, Pantone, Inc.
 Carmine Matarazzo, Technical Director/Print Division, Pantone, Inc.

COLOR

PANTONE® Guide to Communicating with

by Leatrice Eiseman

HOW BOOKS

Cincinnati, Ohio
www.howdesign.com

Contents

Introduction

Of all the forms of non-verbal communication, color is the most instantaneous method of conveying messages and meanings. Before humans learned to appreciate the aesthetics of color, there were far more practical aspects of communicating with color. Our very survival depends on the ability to identify necessary objects and/or warning signals whether they are animal, vegetable or mineral and color is an integral part of the identification process.

Among other uses, color stimulates and works synergistically with all of the senses, symbolizes abstract concepts and thoughts, expresses fantasy or wish fulfillment, recalls another time or place and produces an aesthetic or emotional response.

There is no better place to gauge the effectiveness of color than in the marketplace where it is a vital key in communicating a

© Don Paulson (above and below)

positive, enticing and irresistible image to a product. Often called the "silent salesperson," color must immediately attract the consumer's eye, convey the message of what the product is all about, create a brand identity, and most importantly, help to make the sale. At the very least (as on a Web page or in a print ad), it must create enough interest or curiosity to induce the would-be buyer to find out more about the product (or service).

Much of the human reaction to color is subliminal and consumers are generally unaware of the pervasive and persuasive effects of color. The psychological effect is instantaneous as color stimulates the senses and exerts its power of suggestion. The power that color wields is seen at every level of communication: in corporate identification and logos, signage, advertising on television, billboards, in print media and packaging, on the computer and at point-of-purchase.

As an example of color's power in marketing (and one we can all relate to) as consumers speed down the market aisles, their eyes rest on a package for approximately .03 seconds. In that blinking-of-an-eyelash timing, the package must rivet the observers' eyes, inform them of the package contents and, more importantly, appeal to their psyches.

*A*fter earning the shopper's attention, the package must visually express the value of the goods. If a product is more expensive than a competing product, the color must convey that it is worth the cost and, when goods are priced competitively, the appropriate colors can make a greater impact than the competition's product. With thousands of products lining the market shelves and millions of dollars frequently at stake, the clever use of color can make or break a product line.

For truly effective marketing, package colors must satisfy a "wish fulfillment" or need that the product promises to fulfill. For example: products offering sweet taste or sweet scents should be featured in pink, peach, cream or lavender, while the promise of cool refreshment should be an icy blue, green or blue-green. As explained in the *Color Families* section, each color family conveys specific moods and associations that become part of the symbology that is critical in marketing the product or company image.

Corporations have spent millions of dollars establishing a corporate identity, image and brand equity through their logos, advertising, Web sites and signage; the company must convey an instant message of who they are and what they stand for. IBM will forever be known as the Big Blue: trustworthy and dependable. Coke is red: energy and exuberance. The colors not only identify, they idealize.

Color adds tremendous meaning to communication as it vitalizes the visual message, delivering an instantaneous impression that is, most often, universally understood. This is especially important in conveying a mood or idea where verbiage is not used or understood. Color is a universal language that crosses cultural boundaries in our electronically/technologically/satellite linked "Global Village."

The real intention of marketing communication is to persuade the public at large to become customers — to induce the consumer to respond in a positive way to the message transmitted. In order to convey a meaningful marketing message, the proper use of color psychology is urgent in the following areas:

- The graphic images and brand name

- The packaging as it represents the qualities of the product

- At point-of-purchase where it vies with competitive products and must gain attention

- In all forms of advertising: print, point-of-purchase, TV, Web sites, direct mail, billboards, etc., where it must convince and appeal, especially in a short time span

- Through signage, at the company site or other appropriate areas

- In company logos and IDs

- In the product itself

PANTONE Guide To Communicating With Color not only explains the emotional meaning of each color family, but it also demonstrates hundreds of the most effective color combinations to use in getting that message across.

For anyone involved in the use of color, the classic color wheel illustrated on page 11 is an important graphic tool for understanding the dynamic of color combinations. And basic color terminology will help to clarify the nuances of color.

Speaking Color

Basic Color Terminology

HUE: Color and hue are synonymous and can be used interchangeably. Red, yellow and blue are the primary colors. Green, orange and violet are the secondary colors and tertiary colors are a mixture of two secondary colors.

SATURATION: The intensity of a color is described as saturation or chroma. Saturation is determined by how little or how much gray a color contains. In its purest form a hue is at maximum chroma; these are colors that are not "grayed." They are described as: clear, pure, brilliant, bright, rich, bold, vivid and/or true. The grayer or more neutral a color is, the less its saturation. Less saturated colors are described as soft, muted, subtle, toned-down, misty, dull or dusty.

VALUE: The lightness or darkness of a color is called its value. Lightened values are tints, darkened values are shades and medium value colors are described as midtones. A variation in the light to dark arrangement or design is called a "value pattern." Keeping the value pattern minimized within a limited range creates an understated, subtle and restrained look that is seen as calm and quiet. Colors close in value have "soft edges" between them, while excitement and drama are suggested by sharp changes in value.

Surrounding a focal point with extremes of dark and light contrast will draw the eye immediately to the center of attention.

The perception of a color is affected greatly by its value or saturation; in planning a color combination, value and saturation are as important as the hue. For example, in the red family, a darkened value of burgundy imparts more power than a lighter value of rose pink. A vividly saturated turquoise is more exciting than a pale grayed aqua.

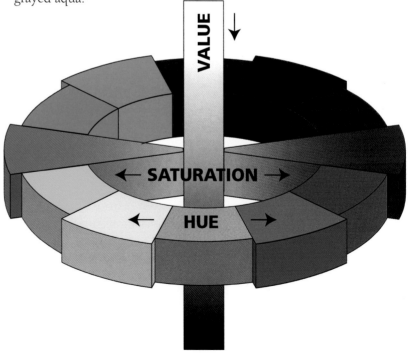

*A*n important graphic tool for creating color combinations, the color wheel is a circular arrangement of the primary, secondary and tertiary colors. It visually illustrates color "temperature" — warm vs. cool — as vital psychological components in delivering a specific color's message. Colors are perceived as warm or cool because of ancient and universal associations. Red, orange and yellow are associated with the warmth of fire and sun while blue, green and violet connect in the mind's eye with the coolness of sea, sky, foliage and outer space.

But changing an undertone can alter the temperature somewhat. Yellow-reds are hotter than blue-reds. The redder the purple, the hotter it gets. Blue-greens are as cool as the water that inspires the liquid-like shades, but yellowed earthy greens are decidedly warmer.

Combinations of warm colors send a more energetic, outgoing, aggressive, active message that demand attention while cool colors are more restrained, reserved and calm — more contemplative than physical. But cool colors show less restraint when they are brightened: as cools become more vibrant, so do their personalities.

The Color Wheel

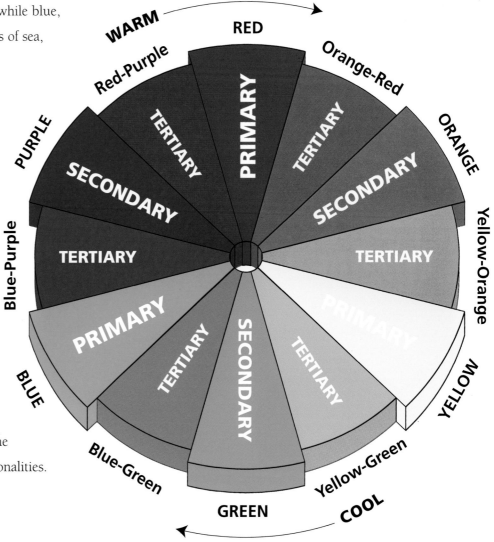

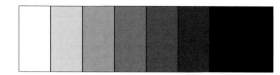

Figure 1

Figure 2

Figure 3

Figure 4

Color Schemes

MONOTONE (Fig. 1): The use of a single neutral color describes a monotone scheme. This includes light to medium grays, beiges, taupes and off-whites that will impart a calm, quiet quality, or a classic understated look. The subtlety can be very appealing for use in more expensive products, but in signage, packaging, advertising or any other graphic application, monotones can be so subtle that they appear unreadable, so some contrast in color or texture is necessary.

MONOCHROMATICS (Fig. 2): The use of one color family in various values or intensities is called a monochromatic color scheme. These combinations can be very effective in imparting subtle nuances such as the refreshing quality of contrasting green foliage or the deliciousness of rich chocolate brown melting into a creamy mocha color.

ANALOGOUS (Fig. 3): Analogous colors are neighboring families on the color wheel. If the combination spans only one-fourth of the color wheel, they are always harmonious as they share the same undertones, for example: blue, blue-green and green. But total harmony is not necessarily a goal because a too-subtle use of color may lack impact. Expanding the analogous group somewhat by adding touches of another neighboring color (green, blue-green, blue and blue-purple, for example) will garner more attention.

COMPLEMENTARY (Fig. 4): Complementary colors means just that — they are total opposites on the color wheel that enhance each other when used as a pair; they "complete" each other. The red family will appear even redder when contrasted with green, as will orange with blue or yellow with purple. They balance each other as they are opposites, one hue is warm and the other is cool. Called simultaneous contrast, each complement seems to vibrate along the periphery of the area where they meet. In their brightest intensities, they literally command attention, so they are especially effective when used in packaging, advertising, at point of purchase, banners, sports uniforms or any other usage where exuberant and instant attention is important. If softer or deeper values of complements are used, the effect is more subtle.

Feeling Color

The colors that we see are invariably influenced by what we feel. From the time of early infancy when our eyes first perceive color, we start to formulate feelings about those colors that invariably carry over into adult life. Some experts believe that humans have an "ancient wisdom," that throughout eons of evolutionary history going back to the beginning of time, we have an associative memory concerning space, form, patterns and colors.

Infants as young as two months prefer colorful objects to non-color. Young children are color-dominant and are more attracted by color than form. As they mature they will generally become more form-dominant, however, many creative people remain color-dominant all of their lives.

While it is true that infants are often attracted to black and white, they do not literally prefer black and white, but it attracts their attention because they see extreme contrast before they see color. As an infant's brain is not fully developed at birth, color is very important as a stimulus to enhance the brain's development.

Eye-tracking studies that record infants' attention span indicate that *regardless of the sex of the child* (forget anything that you have heard about infant boys responding to colors differently than infant girls

— there is no research to support it), red and blue are the most preferred colors when they are infants. Red, in particular aids in the interconnections of brain neurons, which may explain why babies are so drawn to the color. As children grow older, habituation or learning patterns and doing what adults say is appropriate colors their thinking.

Childhood memories are so involved with color that they are indelibly stamped on our psyches forever. We may not even be aware that we are remembering the colors associated with a specific incident, but the tape recorders in our heads are never turned off and even into adulthood we continue to respond to specific colors in a positive or negative way.

For the pre-adolescent and young adolescent, using the "in" colors is very important as it gives them status and recognition and at these ages peer pressure is intense. And color is a great way to be outrageous — what better way to attract attention and make a statement than with yellow-green hair! This is the age group that is intensely trend-driven, so it behooves the designer/manufacturer to be aware of future color directions and forecasts. As we mature, we become more aware of the importance of our need for self-

expression. Trends will still play a part in color choices, but personal tastes and preferences are equally important.

Our cultural backgrounds and traditions influence our learned response and reaction to color as well. For example, Indian mystics believe green is the color that brings great harmony. If you (or your client) had been raised believing that green brings harmony, this color family would evoke positive responses however and wherever it is used.

Each culture has its own unique heritage of color symbolism and each of you is a product of your early environment and so are your clients. When you are dealing with specific cultural groups, it behooves you to do some homework on the background and perception of color in a given culture. As people move from place to place they will often carry their color baggage with them, but some individuals will try very hard to integrate into a newly adopted society by emulating the colors they see around them, so it is best not to make the assumption that all peoples of a particular culture will have exactly the same reaction to color.

With shrinking barriers and increased communication there is a greater homogenization of color exchanges, especially as companies reach out to embrace broader markets throughout the world and old color concepts are changing and expanding. For example, historically white has been a color associated with mourning in the Chinese culture. Currently white is being used not only in everything from T-shirts to wedding gowns, but on airplanes as well. This change in attitude is especially true for the younger people in many cultures who are less bound to tradition and more open to change.

Today, there is an increasing awareness of typically American colors in foreign markets, largely because of American films, TV and the pervasive influence of the music industry. The worldwide Web has spawned a broader communication base than ever before. Out of a cross-cultural exchange a new collective universal color consciousness is emerging.

Cross-culturally, there are some generalities that can be made about the human response to color, largely because of the psychological associations and physiological reactions to color that are universal. For example, why does red always provoke attention? Why is it that in every spoken language; is it the first color to be named after black and white? The psychological association that goes back to the beginning of time is the association of red to blood and fire, two very important elements that are necessary to sustain life.

But the red of bloodshed and fire could also represent danger. So it was very important to pay attention to the color — it triggered the "fight or flight" response and encouraged humans to act accordingly. Throughout time, humans become imprinted with reactions to color and although we may not necessarily flee from red, we *must* pay attention to it.

> **Color Factoid**
> An illusion of movement can be created by color. A flat, rectangular shape can be made to look either convex or concave by moving color from gradations of light to dark and back again.

Seeing Color

The reaction to color is largely (but not entirely) inborn. It is important to understand the process of seeing color in order to appreciate how complex this system we take for granted actually is.

The eye, just like the ear, responds to waves of energy. Both visible light waves and radio waves are among several forms of electro-magnetic energy ranging from cosmic rays at the highest level to electric power transmission at the lowest — these forms of energy differ because they travel at various wavelengths. Specific waves of energy within a limited range are called the visible spectrum, those colors we actually see, while ultraviolet light and infrared are invisible. Hue is established by the dominant wavelength while the luminance (lightness or darkness of a color) is determined by the quantity of electromagnetic energy.

The perception of a color is determined by the wavelengths which bounce back into the retina, a sensory membrane that lines the eyes. The rods and cones of the retina respond to light and, by an electro-chemical process, sends signals to the visual center of the brain. Various receptors are assigned specific tasks and are sensitive to certain vibrations.

Each color "owns" a different wavelength which determines its place in the spectral order. Students of art have long remembered the red, orange, yellow, green, blue, indigo order of colors through the imaginary Roy G. Biv. Rainbows illustrate the perfect example of spectral order. The highest arch of the rainbow (and the longest wavelength) is red, while violet is the shortest and between them are all the other spectral hues. When these waves of light enter our eyes they produce the sensation of illumination and color.

Visual information in the form of light energy is continuously reaching the retina and forming an image to the visual cortex which acts much like a computer, assessing retinal information and relating it to data stored in the memory. It is difficult to draw a clear distinction between the exact function of the eye and the interpretation of the brain because the psychological, emotional and aesthetic response to color is highly complicated. As a result, we can never really separate what we "see" from what we "know."

To further complicate matters, not all of the visual signals that leave the eye go to the visual center of the brain — approximately 20% go to the pituitary gland, the master endocrine gland of the body. There is no better example of the results of glandular involvement than with the color red.

Opposite: Photo by Parish Kohanim

sexy

dynamic

OROLOGI **FENDI**

Red

*T*he pituitary gland really springs

into action when it sees red.

For You—
Only the Best
PH

Since 1869

Available at All Finer Pet Stores

A chemical message is sent to your adrenal medulla and releases the hormone

epinephrine. This alters your body chemistry, causing you to breathe more

rapidly, increases your blood pressure, pulse rate, heartbeat, your flow of

adrenaline and GSR — Galvanic Skin Response (a fancy term for perspiration

and the basis of lie detector tests). These reactions are physiological, and

we have no control over the effect. As a result, red is indelibly imprinted

on the human mind to connect with excitement and high energy.

provocative

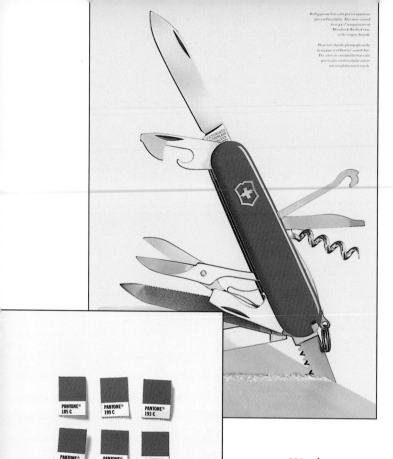

Warm tones are known as high-arousal colors and red, in particular, creates the highest arousal threshold in humans. So from negligees to sports cars to food, red stimulates all kinds of appetites — it is true that red literally can turn you on. In print or at point of purchase, red is virtually unignorable. It has an aggressive nature, commanding attention and demanding action.

Word association studies and consumer response studies tell us that the consumer sees red as passionate, provocative, exciting and dynamic. It's also seen as the sexiest of all colors and is equally seductive in the marketplace.

Any design done in red takes on a red "persona." The person buying a sporty red sportscar subliminally believes that he or she will be magically transformed into a sexy, daring and dynamic person. As to whether red cars get more

speeding tickets — statistical evidence does reveal that red vehicles do get more speeding tickets, but only if the car is a warm yellow red like tomato, not a cool blue red like burgundy. Evidently sharp-eyed highway patrolmen have a higher arousal threshold for warm reds as well!

When red tones are deepened to shades of burgundy, they still maintain the inherent excitement of the closest primary or focal "mother" color from which they came, but are more subdued. The consumer responds to these wine tones as rich, refined, expensive; they see the shade as more authoritative, mature, lush, opulent and elegant than vivid red. So burgundy would be a good choice for expensive products like automobiles.

romantic

youthful

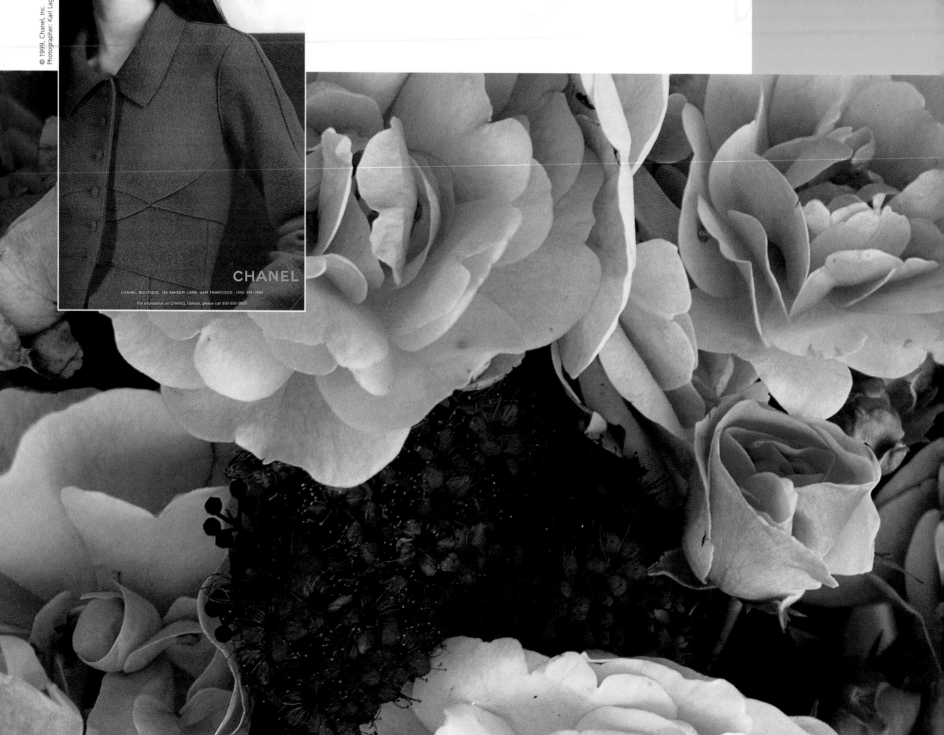

CHANEL

CHANEL BOUTIQUE, 155 MAIDEN LANE, SAN FRANCISCO (415) 981-1550

For information on CHANEL fashion, please call 800-550-0005

Pink

*D*epending on its value or intensity,

pink has diverse mood swings.

Vivid, shocking or hot pinks share the same high energy and spirit of mother red. They're seen

as energetic, youthful, and create a feeling of movement and wild abandon. They're fun and

exciting, but riskier to use than red because they are perceived as faddish — they don't age

as well as red. The best use of these vivid colors is for less expensive, trendy products like

toys (especially dolls) and plastic novelty goods. Be cautious of bubble-gummy pinks

that look immature and artificial — they impart a tacky look to more expensive

products. Vibrant, voluptuous pinks are a favorite of the cosmetic industry, as they

PANTONE®
1895 C

create great attention at point of purchase, when a sultrier,

more up-scale and sophisticated look is the goal. Magenta

and fuchsia pinks that lean to red or purple are perceived

as more "grown-up" as they are both sensual and theatrical.

The lighter, less saturated pinks are watered-down red with all the intensity removed. The

raw sensuality of red is gone — what remains is romanticism. Although there is less male

bias to pink than ever before, pink is still seen primarily as tender and feminine. Dusty pinks

and mauves are viewed as soft, subtle and

sentimental.

Before the texture ever hits the tongue, pink

is perceived of as sweet-tasting and sweet-

smelling. Products such as food and beverage

or cosmetics, perfumes and bath products that suggest sweet scents or sweet tastes would be well advised to use a light to medium pink. Pink and rose are seen as "healthy," optimistic colors (remember "looking at the world through rose-colored glasses?").

Pink can give a rosy glow to any color skin and, in fact, make it look healthier. It's an excellent color for use in health care products, cosmetic products and facial salons, spas or the packaging of any product that is connected to these areas.

PANTONE®
368 C

PANTONE®
243 C

Orange

*T*emperature-wise orange is seen as the hottest of all colors.

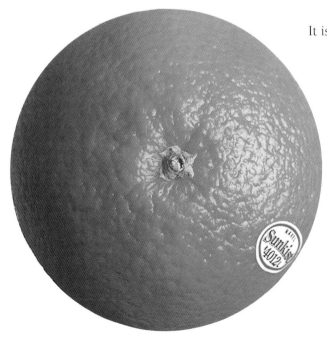

It is also a high arousal color invariably associated with autumn's burnished foliage or the radiant shadings of sunset — glowing and vital. In its most vivid intensities, it is perceived as a color that shouldn't be taken too seriously; a dramatic exclamation point generally preferred by the extroverted personality. It's seen as playful, gregarious, happy and childlike — children between the ages of three to six have a predilection for it, as do adolescents. Orange contains some of the drama of red, tempered by the cheerful good humor of yellow.

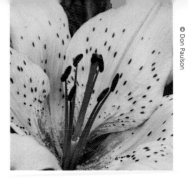

© Don Paulson

It is an excellent color for toys, games, inexpensive plastics and any novelty product that would appeal to the younger or young-at-heart age groups. In graphic applications, it can give a giddy, comedic and cartoon-like impression, so it is not a good choice for conveying a serious message.

The most frequent negative association to bright fluorescent orange is that it's loud. In its neon intensities, it's the most disliked color, however, vivid orange does have its advantages as it is highly visible at point of purchase.

All orange tones are not loud and/or cheap and it is a very dated concept to believe that they are. Orange radiates with warmth and vitality and really shows itself well in "ethnic" themes and combinations, especially where the product or theme speaks of a certain culture, such as Mexican salsa red-oranges or Indian curries.

Orange, along with red and yellow have been shown to exert a measurable effect on the autonomic nervous system, which stimulates the appetite. Taste-wise, it is inevitably connected to the sweet tang of the fruit that bears its name. Fast food restaurants have used warm colors such as

I miss my lung, Bob.

California Department Of Health Services.
Funded By The Tobacco Tax Initiative.

ABSOLUT
Country of Sweden
MANDRIN

Absolut Mandrin is made from
a unique blend of natural mandarin
and orange flavors and vodka
distilled from grain grown in
the rich fields of southern Sweden.
The distilling and flavoring of vodka
is an age-old Swedish tradition.
Vodka has been sold under the name
Absolut since 1879.

40% ALC./VOL. (80 PROOF) 1 LITER
IMPORTED

ABSOLUT ARRIVAL.

TBWA/CHIAT/DAY © V+S Vin + Sprit ab

red, yellow and especially orange to entice people in for instant appetite appeasement. However, these eateries are now more neighborhood friendly and are decorated with colors that blend with the environment, but the appetite-appealing warm colors calling out to you from the signage on the street generally remains in the orange, red and yellow range.

Research reveals that the lighter shades of orange such as peach, apricot, coral and melon have some of the most pleasant word associations. These softer shades are pleasing to the sophisticated eye and very appealing to the upscale or affluent market. They are nurturing, approachable, tactile colors, that, just like the appeal of a velvety peach, people have to reach out to touch or taste.

Peach tones are excellent for use in healthcare products, dining areas, food service and food packaging because they are subtle appetite stimulants and always associated with

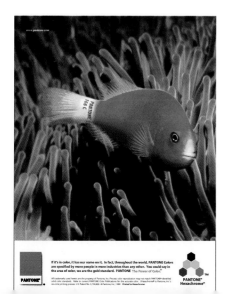

deliciousness. Just as with rose-tones, peach imbues an area with healthy, flattering color, so it is recommended for use in makeup salons, beauty spas, in beauty products and/or packaging.

Jambaism No. 1

YOUR BODY IS A TEMPLE. LITTERING IS STRICTLY PROHIBITED.

Jamba Juice

PANTONE®
Orange 021 C

PANTONE®
383 C

PANTONE®
347 C

PANTONE®
1505 C

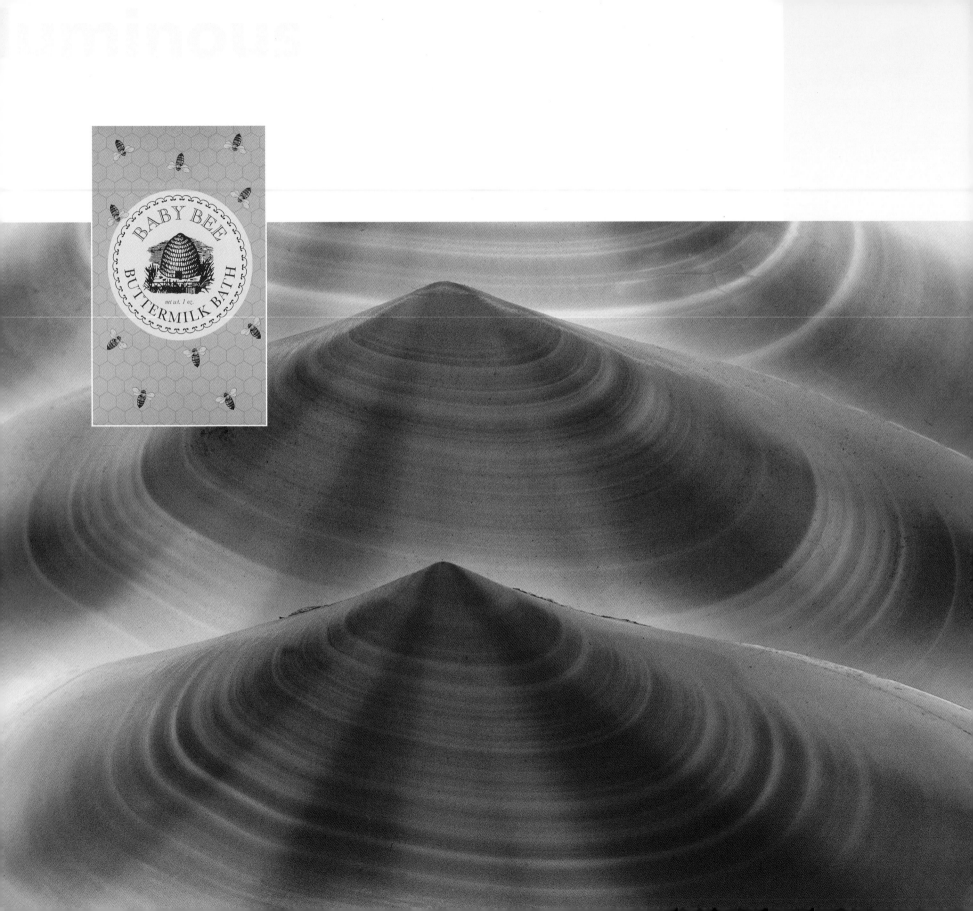

BABY BEE
BUTTERMILK BATH

net wt. 1 oz.

Yellow

*I*n every society, yellow is equated

with the splendor and heat of the sun.

Yellow emulates sunshine, light and warmth. It is a color that is identified with

imagination and enlightenment, glowing with the intensity of sunlight itself. In the

lightest variations, consumers see yellow as cheerful, mellow and soft to the touch.

Bright daffodil yellows are equally cheerful, although more energetic and eye-

catching than the paler yellows, an excellent color to use at point of

purchase or in displays because the eye "sees" highly reflective yellow

before it notices any other color. Unlike other hues that deepen with

saturation, yellow becomes brighter when it is highly saturated.

Shades of yellow that can be described as delicious such as tasty shades like banana cream or custard are best used, for example, in food service areas, food products, dining areas, or linens for the tabletop. Lemon yellow is also a happy color associated with sweet somewhat citrusy tastes, but it is less sophisticated than the cream yellows.

For the American consumer, the most preferred yellows are creamy and very warm or sunbaked, while the greenish yellows are not especially popular. However, all shades of yellow, especially green-based, are acceptable in Asian cultures. The closer yellow gets to green, the more it is associated with tart and acidic tastes.

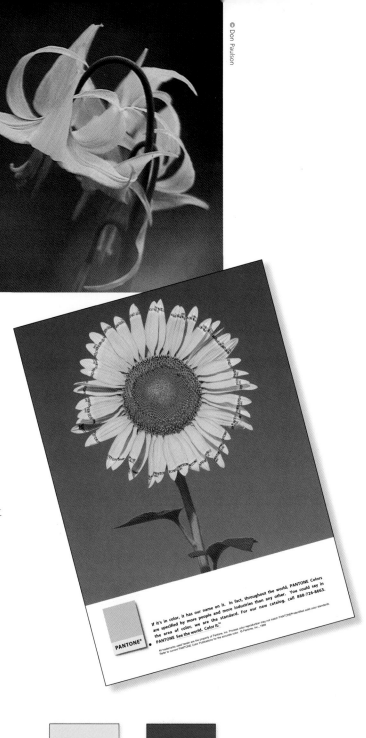

© Don Paulson

Of all color combinations in nature, yellow

and black is the most unignorable — because of

its ancient associations to dangerous predators, the colors of stinging insects

and other exotic or scary creatures that say: you'd better pay attention to me.

For that reason, it's an excellent combination for signage or the packaging of

products that blatantly call out from the market shelves. Its message is less than

subtle, it's the "pow" in powerful, an industrial strength symbol suitable to products

for heavy duty usages — a combination of black's strength and yellow's energetic but

user-friendly connotations.

PANTONE®
109 C

PANTONE®
286 C

rustic

sheltering

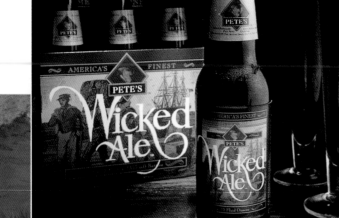

Brown

Brown is the ultimate earth color associated
with hearth and home, substance and stability.

Historically, brown is revitalized in cost-conscious periods because of its association
with a down to earth durability.

durable

More than any other color, brown must be thought of in terms of usage and
context. The various tones of brick, brown, tan, clay and terracotta are seen as
the most rooted, protective and secure of all shades because they are inevitably
connected to the earth. The color of earth generally elicits a positive response,
however, some consumers relate to brown as dirt or dirty — not a pleasant
association that has often been problematic in the fashion industry.

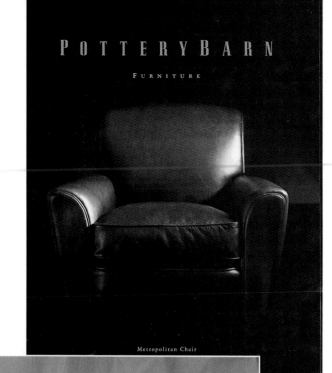

Metropolitan Chair

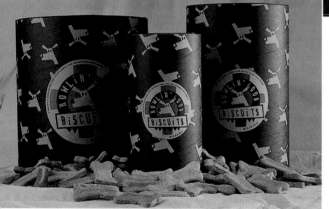

More recently brown has earned greater visibility and respect due in large part to the panache of designer coffees like richly brewed espresso or the deeply polished patinas of brown leathers in both the stylish worlds of fashion and interiors.

In the home furnishings industry, brown has always had higher acceptability because of its traditional connection to the stability of earth. People feel secure in a brown interior, an imprinted reaction that goes back to the days of cave dwellings — the only environment where there was absolute safety from predators.

At one time, it was thought that warmer, yellow-based browns were "de-classé" and acceptable only for country or casual looks or in

PANTONE®
490 C

PANTONE®
127 C

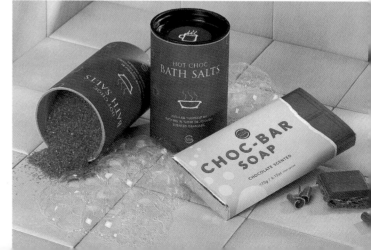

utilitarian products. That is no longer true, as the more rustic terracotta colors are successfully combined in many "up-scale" looks.

The homey, earthy aspect of brown has played very well in the food industry for many years. The immediate response to brown breads, brown rice, brown grains and cereals is that it is wholesome, healthy and organic. Interestingly, brown also represents the opposite extreme of the most delicious and enticing food — luscious chocolate. Whether wholesomely unprocessed or decadently delicious, brown is well connected to good tastes, appropriate to the products involving foodstuff or environments where food is served.

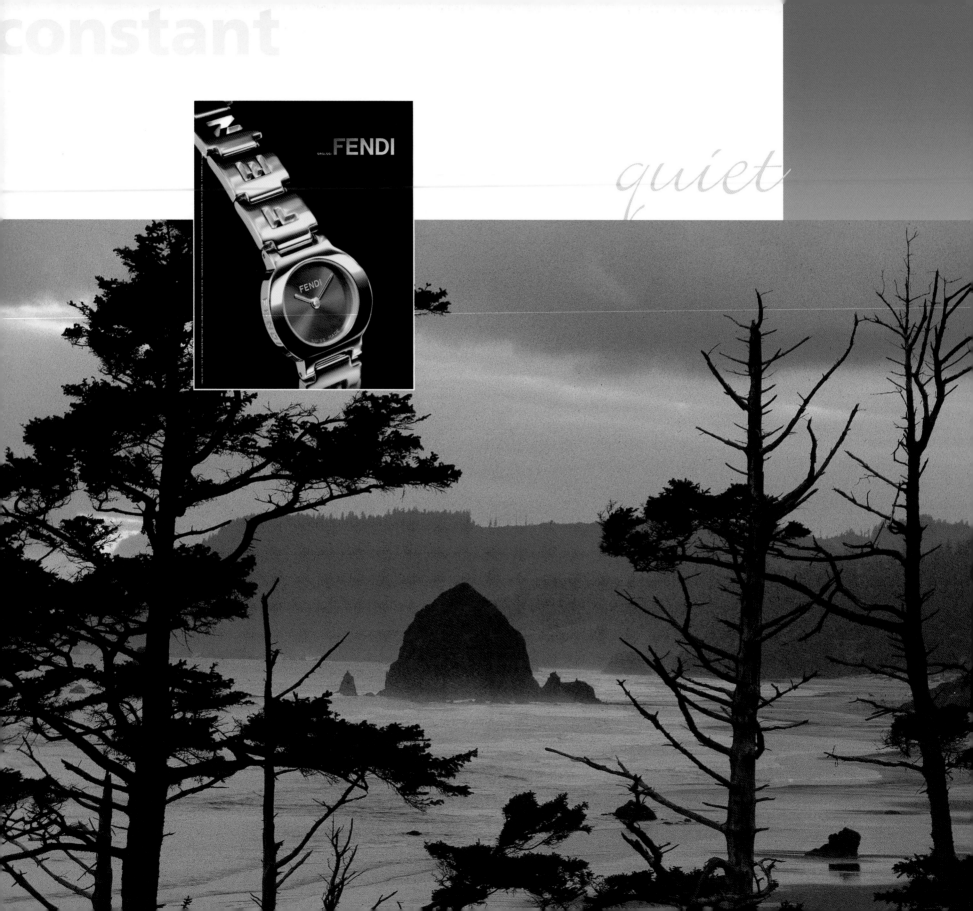

cool

Blue

As it is strongly associated with sky and water,

blue is perceived as a constant in our lives.

The ocean has never disappeared and the sky has never fallen. Because of this association, blue is seen as reliable, trustworthy, dependable and committed; it inspires confidence, making it ideal for Web sites, packaging, products or corporate IDs where those messages are important. Notice how many banks and financial institutions use blue backgrounds in ads as well as decor.

It's also restful. In the presence of a blue environment, we feel calm. Humans are soothed and replenished when they view blue and there is some evidence that when blue enters our line of

vision, the brain sends out chemical signals that work as a tranquilizer. For this reason, many hospitals now use blue on the surgeons, nurses and walls of the operating room. Blue is an excellent choice for areas demanding mental concentration or for products and environments that invite concentration or relaxing, "meditative" moods.

Darkening any color so that it moves closer to black invests the hue with power. Deep Navy Blue is the most serious and powerful of all blues, and this is why it is frequently used as a uniform color for policemen and airline pilots. It's instant authority and credibility in any business. Concentrated and over-abundant black can look ominous, but navy is more friendly and approachable.

Forget the sweeping generality that all blues are serene and sedate. Brilliant blues add a whole new dimension to this color family and electric blue becomes dynamic and dramatic, an engaging color expressing exhilaration. Periwinkles are seen as the warmest and most playful blues as they carry an undertone of purple, bringing some of the energy of red into the picture. Consumers see teal blue as rich, unique and definitely up-scale. They are viewed as pleasing to the eye and combine

PANTONE®
324 C

PANTONE®
659 C

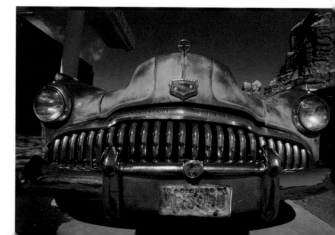

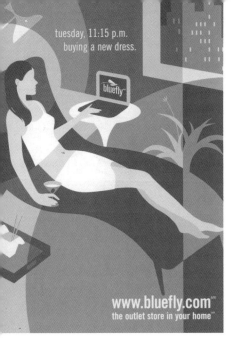

well with many other colors. It is one of the least "gender-specific" colors, having equal appeal to both men and women.

Traditionally, blue is not a color that has been used extensively for the packaging of food because of the human aversion to a color that is unusual in familiar foods. Blue milk or a blue steak would be considered disgusting because humans are not accustomed to seeing blue in those liquids or foods.

Blue has been used successfully, especially in packaging and/or containers for some liquids like designer drinking waters because of blue's connection to clean water. Trendy new "designer" foods in recent years have very successfully utilized unusual colors (like blue corn chips or candies) precisely because they are so different. Children generally love unexpected colors in food because they have not had the years of prior conditioning that adults have experienced.

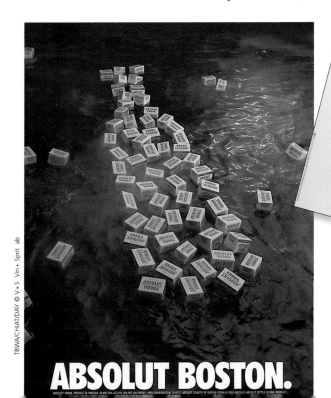

Green

*O*f all the colors in the spectrum,
green offers the widest array of choices.

Blue-greens represent the best qualities of the two "mother" colors — blue and green, always eliciting pleasant responses. Although they are thought of as cool, clean colors especially when combined with white, there is an underlying element of appealing warmth in blue-greens as in the temperature of warmer, tropical waters. Blue-greens and aquas are especially appropriate to either the packaging or actual color of personal hygiene or beauty products as they impart a soothing quality and are flattering to every skin color.

Word association tests show that most people will link many shades of green to nature. Using nature as inspiration, think of the myriads of green foliage

that provide a background to plants and flowers of every imaginable color; there are no "clashing" greens with red roses, yellow daisies, purple crocuses, bluebells or marigolds. In every area of design and in a multitude of color combinations, green can be used much the same as a neutral color.

Because of its association with nature and foliage, most consumers respond to mint green as both refreshing and fresh. Bright greens are associated with grass, the first buds of spring and renewal. Emerald greens are elegant, while deep greens are seen as stately tall pines and associated with the refreshing scents and silence of the forest.

Deep greens are also identified with money and prestige. People feel secure and safe in its presence. Just as blue is linked with trustworthiness, so is green. Obviously the darker greens (the same as the color of money) are excellent colors for promoting banks, lending institutions or other businesses where prestige and/or security is a factor.

Yellow-greens are best accepted in a gardening/floral motif, as they are thought of favorably within that context. However, vivid yellow-green tones are most often associated with nausea and illness and for that reason, they are not recommended for healthcare, dining areas, boat or airplane interiors or on products or packaging to be used in those environments!

WEDDINGBELLS

LANDMARK TOMMI

Green Giant

Fresh

GARDEN DESIGN

Color Smart

Kids and adolescents love strident yellow-greens — mainly because adults hate it! Chartreuse is a particularly trendy color and when it is in fashion, the "fashion-forward" types will buy it. It is an excellent attention-getter and just an accent of it captures the eye. It's a fabulous color when used out of context — nothing will rivet the eye more than a picture of a yellow-green hot dog, yellow-green hair, or yellow-green lips!

Olive is a color that doesn't rate well unless it's combined in an interesting, complex way and then it appeals to the up-scale buyer. Just don't call it olive or avocado — the consumer resists those names because they remember seas of avocado carpet from the '60s and '70s. Give it a more romantic or environmentally-correct name like Verdant Moss!

The best greens to use near or around food are the typical vegetable colors like spinach, lettuce, broccoli, etc. We are accustomed to those shades of green in food, so they are not offensive (unless you happen to hate broccoli!). Those vegetable tones would work well for food service, dining areas or on packaging of so-called "healthy" foods. The seafoam greens are also well accepted by consumers; they are non-invasive and have a cooling, calming effect.

PANTONE®
623 C

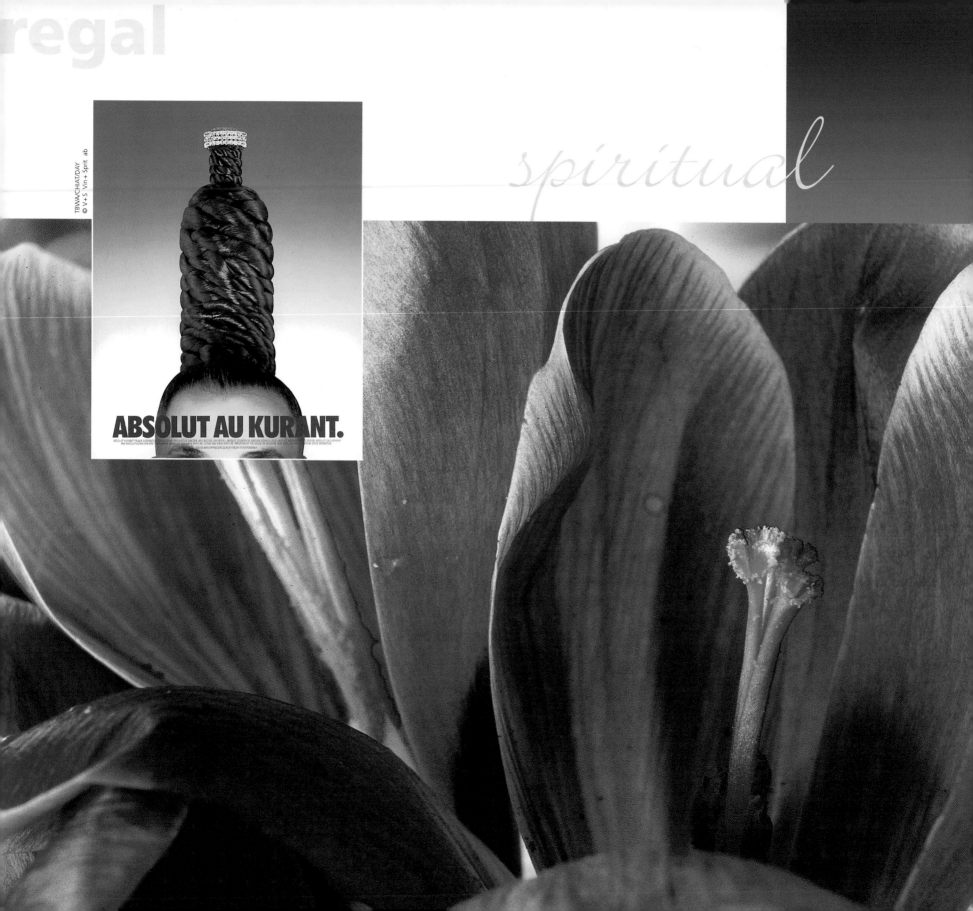

Purple

Purple is a glorious yet complex color,
preferred by very creative and eccentric types.

It can have many meanings — from contemplative to regal, depending largely on the

background and cultural heritage of the viewer.

But purple is something of an enigma. It is both sensual and spiritual — a blend of

the excitement and sexuality of red and the tranquillity of blue — often conflicting

forces which have to be handled with care and a certain sense of daring. It is a much

under-used color for packaging, at point of purchase as well as signage. The presence of

red within the hue is a great attention-getter yet the presence of blue keeps purple a bit

PANTONE®
5265 C

more controlled than red. Depending on the undertone, reddish-purple can be a good substitute for red or bluish-purples for blue when red or blue seems too predictable.

In its more radiant intensities, it is the color most associated with the spirituality of New Age philosophies. It has a futuristic quality that would speak well for products that involve newness and cutting edge technologies as it is a complex color embracing a diversity of undertones linked with artistry and uniqueness.

Just as the name implies, deeper royal purple is also viewed as regal and majestic so the perceived value of deeper purple products is greater than with many other colors. This is especially true in European markets or for people with

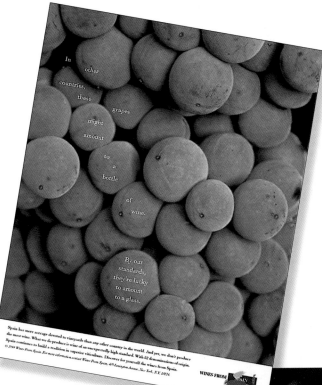

European backgrounds or sensibilities. The presence of a grayed undertone lends more sophistication and subtlety to purples. Just as pink is the diluted version of red, lavender is the softer side of purple. There is a sentimental, nostalgic, genteel aspect to this shade of purple. At one point in time, it was thought of strictly as an old fashioned little old ladies with lavender hair color, but it is no longer strictly associated with old age or for women only, primarily because of its wide acceptance in the fashion industry for every age and gender group. However, there is still a delicacy and refinement attached to the lavender tints and they are very much associated with sweet tastes and sweet scents, especially floral scents. Grape and purplish berry shades are also associated with the sweetness of those fruits.

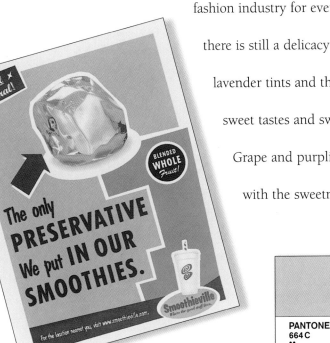

PANTONE® 664 C	PANTONE® 687 C

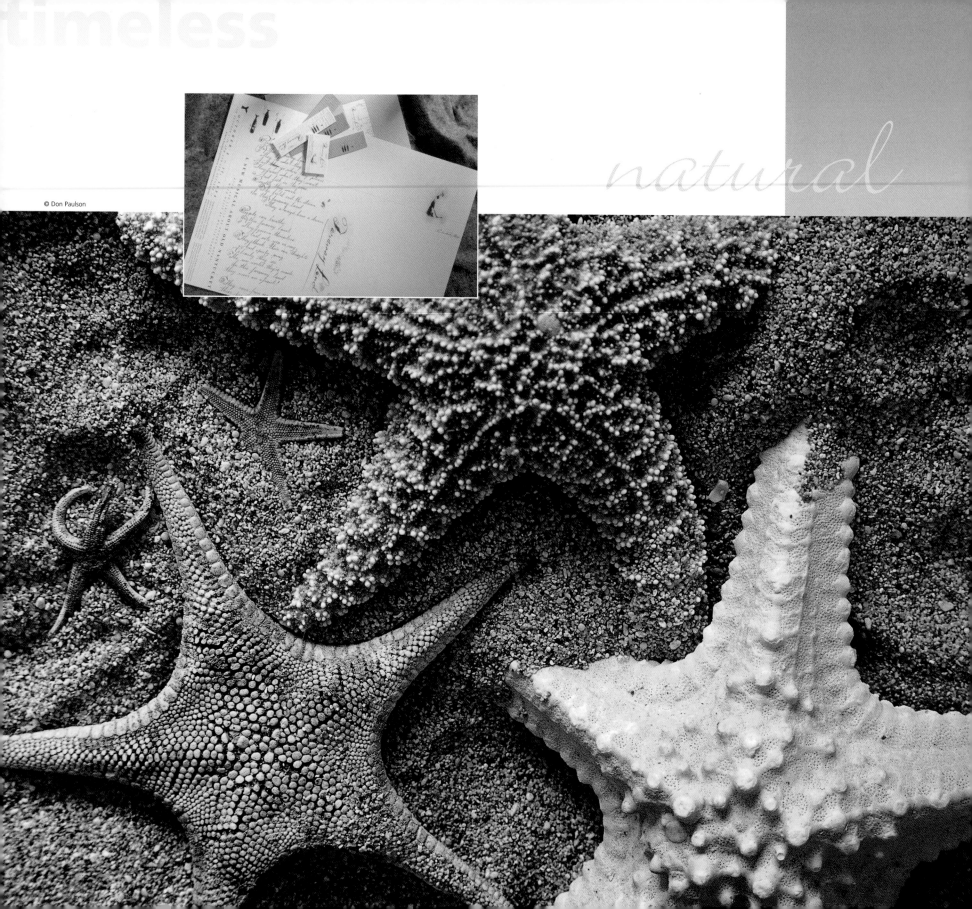

timeless

natural

© Don Paulson

Neutrals

Although classified as achromatics,

literally without color...

Essentials
by *Karastan*

Wool Weave

the neutral tones of beige, gray and taupe are still a psychological presence that impart

a message of dependability. Taupe is sometimes referred to as "greige," literally the

combination of gray and beige. Neutrals may also be described as monotones

(see Color Schemes on p.12).

These neutral tones are identified with time and antiquity, the durability of

ancient monuments, buildings and temples. Like the rock of Gibraltar, the

Pyramids or the sands of time, they are seen as solid, enduring, timeless, and,

PANTONE®
466 C

above all classic; these qualities are transferred to the product or environment in which neutrals are used. Neutrals should be used whenever durability, permanence and dependable performance and quality is of utmost importance, whether in interiors, packaging, clothing or other products.

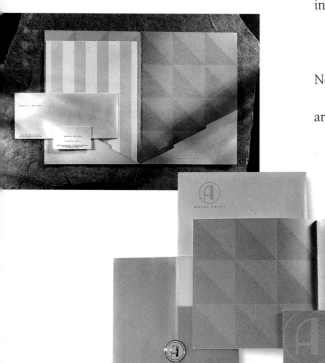

Neutrals are regarded as "safe" and non-offensive. They will not date a product because they are always in style. However, there are many nuances of the various neutrals because of their undertones. These undertones can radically shift the temperature of a neutral and change its psychological impact. For example: a warm gray is never as serious as a calm, collected, cool gray. A warm sandy beige is friendlier than a cool white.

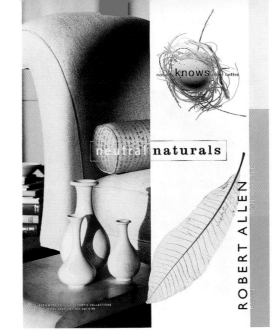

Light to medium grays are the most "non-committal" of all colors. The most neutral of all the neutrals — it is highly recommended for work surfaces where color matching takes place because of its total neutrality. It will not compete with other colors and is highly recommended as a buffer between bright colors to reduce the intensity of the brilliance.

As grays approach black, they start to take on much of black's power and presence. But charcoal grays are never as threatening or overpowering as total black can sometimes be, especially in living environments, clothing or packaging. Silvery grays can take on a very futuristic, techno look as they are inevitably connected to minimal, spare and sleek images.

lightweight

pristine

pinehurst candles

White

*N*ot unexpectedly,

white imparts purity and simplicity.

However, it's important to remember that the human eye sees white as a

brilliant color. For that reason it works well for contrast, in signage, at

point-of-purchase, in packaging, or any other usage where it will catch

the eye. It imbues products with a sense of clarity and cleanliness.

For infants' products, or products involving personal hygiene and

health, this is an excellent message to impart.

BURT'S BEES™

BABY BEE™

pint-sized
BUTTERMILK
BATH SOAK

7.5 oz

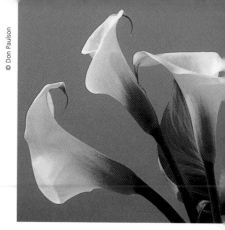

If white is thought of in terms of pigments and dyes, it is seen as the absence of color; if white is thought of in terms of light, it is the presence of all color as Sir Isaac Newton discovered in his experiments with prisms where he demonstrated that white light contained all of the colors of the spectrum, while black light had none.

Unrelieved by a distinctive or warming contrast pure white, in interiors, can create a starkness that will lack any sense of welcome or warmth. Pure white is the symbol of absolute minimalism, the "clean slate" against which all other colors may contrast. It is the ultimate contrast to black, but in print, packaging and product design it can

also give a very generic "plain wrap" impression unless embellished with stylish graphics and/or some touch of another color or finish.

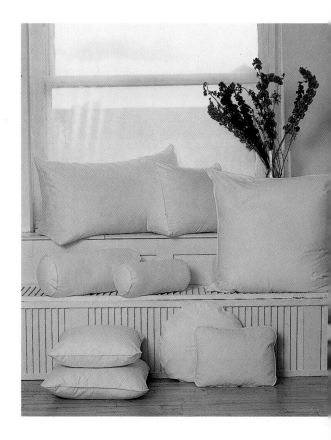

Off-whites are a bit more "friendly," especially when skewed to the warm side. Creamy whites are perceived of as delicious — excellent for dining areas and food packaging. Vanilla white also suggests light, pleasant scents and tastes.

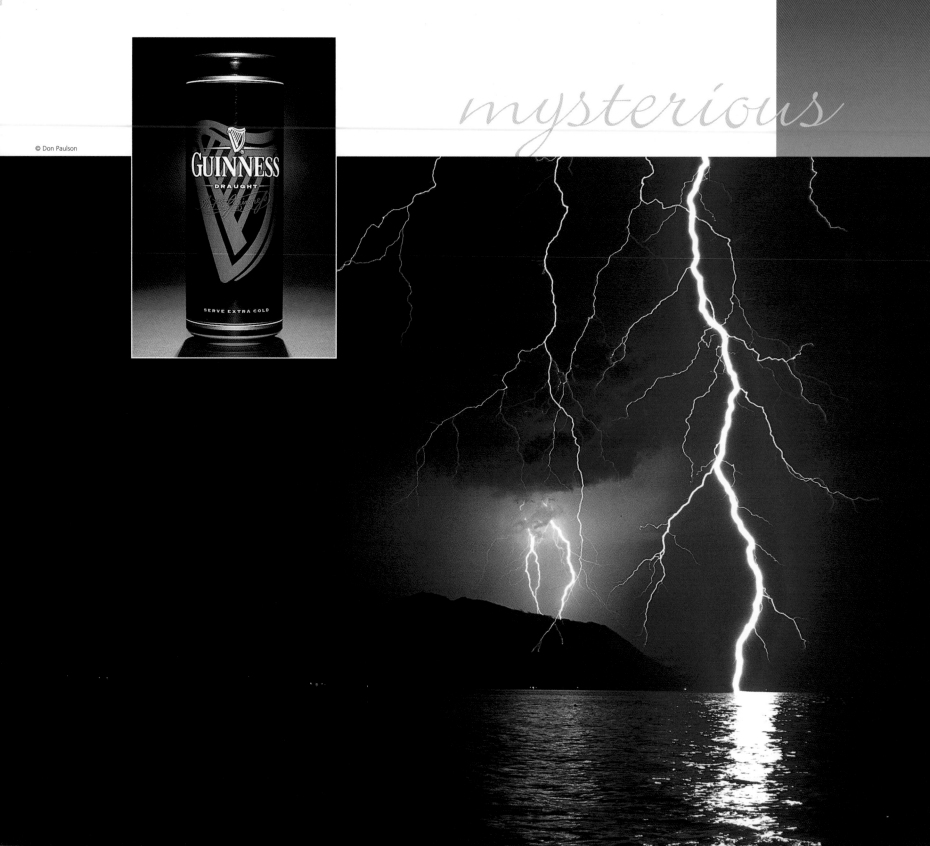

powerful

mysterious

© Don Paulson

Black

Indelibly imprinted in the human mind,

black is most closely associated with...

elegant

the magical mysteries of night. That impenetrable, after-dark, powerful essence of black is

seen in every product category as the most sophisticated and highly stylized shade. The

consumer sees black as the most powerful, dramatic, elegant and expensive presence.

This extends into food packaging where the consumer will actually pay more for

this "gourmet image."

In recent years, attitudes about black have changed more than any other color

with positive associations outweighing the negative. In some cultures,

black is still associated with mourning, however, that somber attitude has given way to sophistication as more people identify it with black limos, black tie events, polished granite, expensive leather and many other up-scale looks that give black an elegant caché.

Too much black might be ominous and "overkill" — a black shirt and tie with a black suit might smack a bit of the "Mafioso"; an all black interior would look foreboding without some touches of color relief. Obviously packaging, signage and advertising should never be completely black because the message would not be legible.

But black does give the message of strength wherever it is used. In consumer products, this is a definite plus wherever power, potency, longevity and weight is implied. Black will

always seem to weigh more than other colors, even though, in fact, it may not. This could be a plus for appliances or equipment or any other product where weight implies a more solid, durable substance. But because of this association to heavier weight, a black airplane or boat would not be a good idea — if it's too heavy, it may sink or fall out of the sky! That is not a problem with automobiles, motorcycles or trucks, because the weight is seen as a plus when it rests on terra firma.

Black is the extreme contrast to white in every way, therefore they make for the most perfect marriage of opposites. Black and white is the quintessential and most classic combination of strength and clarity, power and purity.

Color Selection Process

- *Define the message: Is it serene, sensual or spiritual?*

- *Should it suggest sweet tastes or scents, cleanliness or class?*

- *Select the dominant colors that conveys the message.*

- *Choose supporting colors to reinforce the message.*

- *Fine tune choices for appropriateness to target audience.*

- *Check competitors' colors for similarities.*

- *Utilize the combinations starting on page 64 as a "launching pad."*

Color Combination Cues

In order to establish an immediate message, color combinations should contain visual color cues that trigger specific responses — those that best express the intention and/or purpose of the product or service. As a general rule of thumb, there should be a rank order of dominant color, subordinate color and color accents. Word association studies show that the dominant colors in the following list will generally elicit the responses listed. Note that for most colors, the positive aspects are far more prevalent than those that might be thought of as negative. These responses, as well as the associations and origins of color reactions explained in the "Color Families" section will assist you in defining and creating the most effective color combinations and moods.

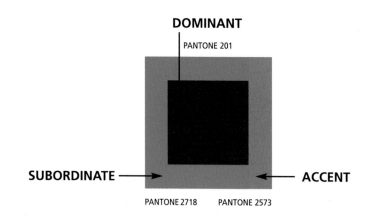

DOMINANT

PANTONE 201

SUBORDINATE → ← **ACCENT**

PANTONE 2718 PANTONE 2573

Dominant Colors and Responses

Bright Red: Exciting, Energizing, Sexy, Hot, Dynamic, Stimulating, Provocative, Dramatic, Aggressive, Powerful

Bright Pink: Exciting, Happy, Hot, Attention-Getting, Energetic, Youthful, Spirited, Fun, Trendy, Wild

Light Pink: Romantic, Soft, Sweet, Tender, Cute, Babies, Delicate

Dusty Pink: Soft, Cozy, Subtle, Dusky

Mauve: Soft, Subdued, Quiet, Sentimental

Burgundy: Rich, Elegant, Refined, Tasty, Expensive, Mature

Fuchsia: Bright, Exciting, Fun, Hot, High Energy, Sensual

Brick Red: Earthy, Strong, Warm, Country

Terracotta: Earthy, Warm, Wholesome, Country, Welcoming

Orange: Fun, Whimsical, Childlike, Happy, Glowing, Vital, Sunset, Harvest, Hot, Juicy, Tangy, Energizing, Gregarious, Friendly, Loud

Peach: Nurturing, Soft, Fuzzy, Delicious, Fruity, Sweet, Inviting

Light Yellow: Cheerful, Happy, Soft, Sunny, Warm, Sweet

Bright Yellow: Enlightening, Sunshine, Cheerful, Friendly, Hot, Luminous, Energy

Greenish Yellow: Lemony, Tart, Fruity, Acidic

Golden Yellow: Autumn, Flowers, Harvest, Rich, Sun, Warm, Wheat, Comforting, Sunbaked, Buttery

Cream: Smooth, Rich, Warm, Neutral, Soft, Classic, Delicious,

Beige: Classic, Sandy, Earthy, Neutral, Soft, Warm, Bland

Earth Brown: Rooted, Wholesome, Sheltering, Masculine, Woodsy, Warm, Durable, Secure, Rustic, Earth, Dirt

Coffee or Chocolate: Rich, Delicious

Red Purple: Exciting, Sensual, Flamboyant, Creative, Unique

Deep Plum: Expensive, Regal, Classic, Powerful, Elegant

Blue Purple: Mystical, Spiritual, Futuristic, Fantasy, Meditative

Lavender: Nostalgic, Delicate, Sweet Scented, Floral, Sweet Taste

Grape: Sophisticated, Sweet Taste, Subtle

Orchid: Exotic, Flowers, Fragrant, Tropical

Light Blue: Calm, Quiet, Peaceful, Cool, Water, Clean

Sky Blue: Calming, Cool, Heavenly, Constant, Faithful, True, Dependable, Happy, Restful, Tranquil

Teal Blue: Pleasing, Rich, Classy, Expensive, Unique

Bright Blue: Electric, Energetic, Vibrant, Flags, Stirring, Happy, Dramatic

Navy: Credible, Authoritative, Basic, Classic, Conservative, Strong, Dependable, Traditional, Uniforms, Service, Nautical, Confident, Professional, Serene, Quiet

Turquoise: Ocean, Tropical, Jewelry

Aqua: Cool, Fresh, Liquid, Ocean, Refreshing, Healing

Light Green: Calm, Quiet, Soothing, Neutral

Dark Green: Nature, Trustworthy, Refreshing, Cool, Restful, Stately, Forest, Quiet, Woodsy, Traditional, Money

Olive Green: Military, Camouflage, Safari, Classic, Drab

Bright Green: Fresh, Grass, Irish, Lively, Spring, Foliage, Outdoorsy

Bright Yellow-Green: Artsy, Sharp, Bold, Gaudy, Trendy, Tacky, Slimy, Sickening

Lime: Tart, Acidic, Refreshing, Fruity, Lively

Pure White: Pure, Clean, Sterile, Innocent, Silent, Lightweight, Airy, Bright, Glistening

Black: Powerful, Elegant, Mysterious, Heavy, Basic, Bold, Classic, Strong, Expensive, Magical, Nighttime, Invulnerable, Prestigious, Sober

Charcoal Gray: Professional, Classic, Expensive, Sophisticated, Solid, Enduring, Mature

Neutral Gray: Classic, Cool, Sober, Corporate, Practical, Timeless, Quality, Quiet, Ghostly

Taupe: Classic, Neutral, Practical, Timeless, Quality, Basic

Silver: Classic, Cool, Expensive, Money, Valuable, Futuristic

Gold: Warm, Opulent, Expensive, Radiant, Valuable, Prestigious

Color Combinations

\mathcal{M} ost of the color "moods" or themes on the following pages are illustrated in combinations of three colors. If more than three colors are appropriate, additional choices can be made from another color grouping within the same theme. For example, on page 81 (the *Sensual* theme), the first combination includes two variations of red and a purple: PANTONE 207, PANTONE 208 and PANTONE 2593. The combination immediately to the right includes a dark blue, a deepened purple and a vibrant fuchsia: PANTONE 2755, PANTONE 261 and PANTONE 241. Fuchsia would add a fourth color as well as an element of excitement and drama to the original choice.

If a fifth (or more) color were to be added, any other color on the page would be a possibility for expanding the original choice as they blend well and share the same mood. The information found on page 10–12 (*Speaking Color*) can further expand the possibilities of color schemes.

Color Factoid

The best color to use as background for color matching purposes is a neutral gray tone.

Some combinations, depending on the usage and desired effect, may utilize only two colors. For example, the strength of vibrant yellow against a stark black more than implies *power,* lipstick red against a plush purple certainly suggests *sensuality.* The design elements and the nature of the composition must come into play as well; however, many messages are further enhanced by the use of more, rather than less, color.

PANTONE Black

PANTONE 116

POWERFUL

PANTONE 2587

PANTONE 219 PANTONE 326

PLAYFUL

A *playful* mood is even more whimsical when there are at least three colors bouncing off of each other. A *festive* mood literally makes the eye dance with its juxtaposition of three or more active happy colors. Hunter green and mahogany brown certainly

suggest a *traditional* feel, but adding some claret wine to the mix enhances the flavor without destroying the mood.

PANTONE 2718

PANTONE 157 PANTONE 115

FESTIVE

PANTONE 209

PANTONE 560 PANTONE 4625

TRADITIONAL

There are no absolute rules about how many colors are appropriate in a combination. The final choice rests in the designer's eye. But the mood of the piece will be determined by the chosen colors. The following color combination pages will help to define those moods.

Serene

*P*icture a perfectly placid blue sky reflected in a clean, clear blue-green sea, an occasional puff of white clouds to accent the quiet repose. These are light to mid or deep tones of blue, blue-green, green or lavender that may be accented with cloud or snow white for a pristine contrast. As brights may jar the peace, use them sparingly as accent.

CERTIFIED BAHAMAS SPECIALIST

PANTONE 297	PANTONE 543	PANTONE 441	PANTONE 2975	PANTONE 2717	PANTONE 644
PANTONE 278 — PANTONE 442	PANTONE 324 — PANTONE 649	PANTONE 2706 — PANTONE 5165	PANTONE 5315 — PANTONE 580	PANTONE 317 — PANTONE 663	PANTONE 577 — PANTONE 420

PANTONE 400	PANTONE 441	PANTONE 550	PANTONE 443	PANTONE 5425	PANTONE 2756
PANTONE 664 — PANTONE 277	PANTONE 537 — PANTONE 4545	PANTONE 578 — PANTONE 5305	PANTONE 535 — PANTONE 5803	PANTONE 666 — PANTONE 537	PANTONE 444 — PANTONE 442

PANTONE 5405	PANTONE 534	PANTONE 546	PANTONE 629	PANTONE 625	PANTONE 645

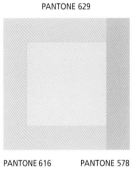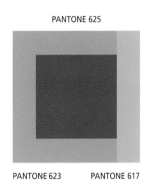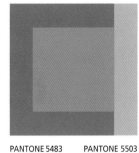

PANTONE 5635 — PANTONE 646	PANTONE 634 — PANTONE Cool Gray 8	PANTONE 549 — PANTONE 551	PANTONE 616 — PANTONE 578	PANTONE 623 — PANTONE 617	PANTONE 5483 — PANTONE 5503

PANTONE 542	PANTONE 565	PANTONE 5783	PANTONE 308	PANTONE 624	PANTONE 624
PANTONE 5507 — PANTONE 536	PANTONE 277 — PANTONE 2905	PANTONE 5483 — PANTONE 5625	PANTONE 647 — PANTONE 343	PANTONE 5483 — PANTONE 618	PANTONE 642 — PANTONE 646

Earthy

This palette typifies a pastoral setting with down to earth values... more country than city, more warm than cool. These mixtures of forested greens, barn reds, cowhide tans and nut browns are best combined with harvest russets, meadow violets or the golden ochres reminiscent of falling autumn leaves, shades that speak of rich abundance.

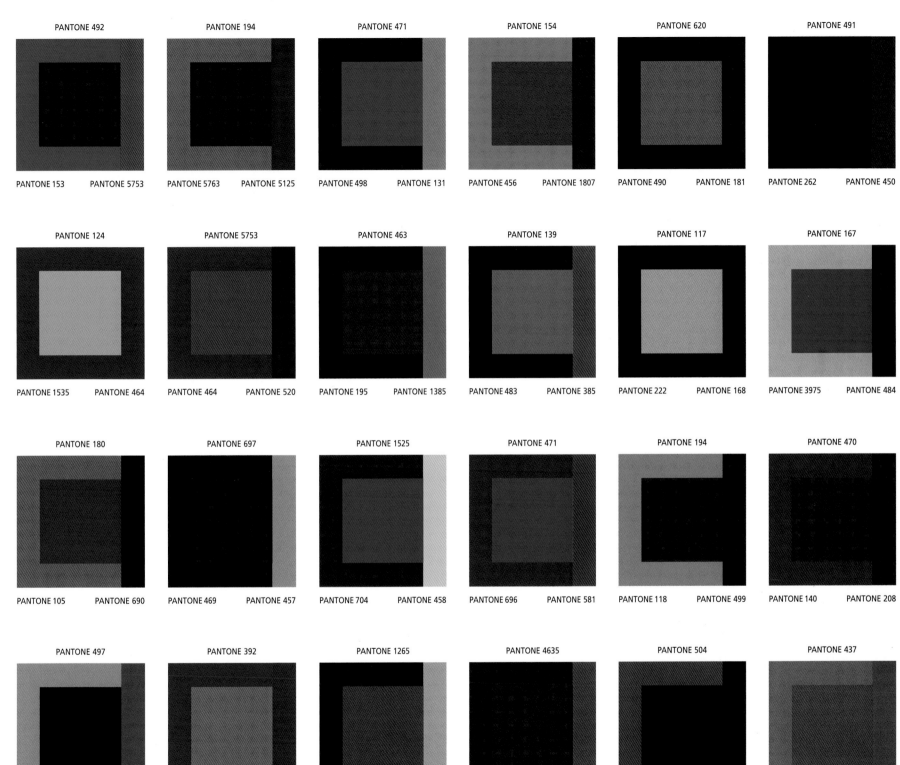

PANTONE 492
PANTONE 153　　PANTONE 5753

PANTONE 194
PANTONE 5763　　PANTONE 5125

PANTONE 471
PANTONE 498　　PANTONE 131

PANTONE 154
PANTONE 456　　PANTONE 1807

PANTONE 620
PANTONE 490　　PANTONE 181

PANTONE 491
PANTONE 262　　PANTONE 450

PANTONE 124
PANTONE 1535　　PANTONE 464

PANTONE 5753
PANTONE 464　　PANTONE 520

PANTONE 463
PANTONE 195　　PANTONE 1385

PANTONE 139
PANTONE 483　　PANTONE 385

PANTONE 117
PANTONE 222　　PANTONE 168

PANTONE 167
PANTONE 3975　　PANTONE 484

PANTONE 180
PANTONE 105　　PANTONE 690

PANTONE 697
PANTONE 469　　PANTONE 457

PANTONE 1525
PANTONE 704　　PANTONE 458

PANTONE 471
PANTONE 696　　PANTONE 581

PANTONE 194
PANTONE 118　　PANTONE 499

PANTONE 470
PANTONE 140　　PANTONE 208

PANTONE 497
PANTONE 111　　PANTONE 1395

PANTONE 392
PANTONE 1675　　PANTONE 193

PANTONE 1265
PANTONE 222　　PANTONE 4515

PANTONE 4635
PANTONE 484　　PANTONE 4495

PANTONE 504
PANTONE 5757　　PANTONE 1815

PANTONE 437
PANTONE 4505　　PANTONE 730

Mellow

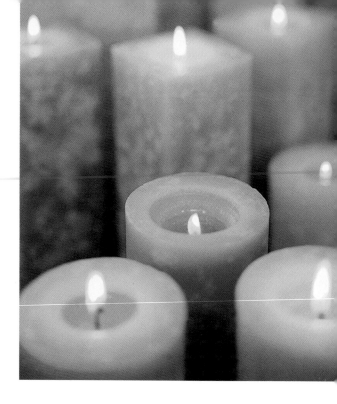

These are docile, caring, wistful colors inviting to be touched. They are best in the light to mid-tones, avoiding contrasts that are dark or bright. There are some cool tones in the mixtures but they veer to the warm side as the dominant theme is comforting softness and warmth.

PANTONE 9162 PANTONE 9182 PANTONE 9161 PANTONE 127 PANTONE 1205 PANTONE 726

PANTONE 9122 PANTONE 9242 PANTONE 9283 PANTONE 9602 PANTONE 9121 PANTONE 9343 PANTONE 155 PANTONE 5875 PANTONE 719 PANTONE 434 PANTONE 5527 PANTONE 4535

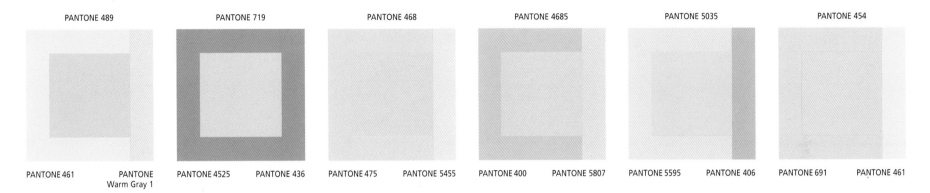

PANTONE 489 PANTONE 719 PANTONE 468 PANTONE 4685 PANTONE 5035 PANTONE 454

PANTONE 461 PANTONE Warm Gray 1 PANTONE 4525 PANTONE 436 PANTONE 475 PANTONE 5455 PANTONE 400 PANTONE 5807 PANTONE 5595 PANTONE 406 PANTONE 691 PANTONE 461

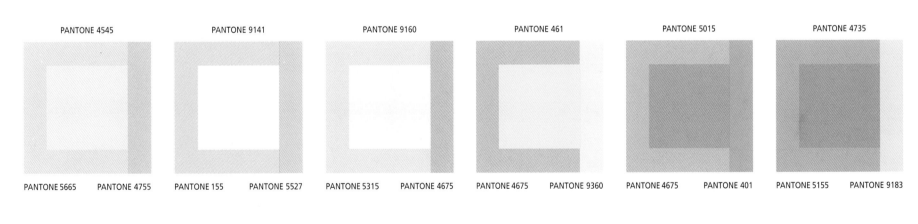

PANTONE 4545 PANTONE 9141 PANTONE 9160 PANTONE 461 PANTONE 5015 PANTONE 4735

PANTONE 5665 PANTONE 4755 PANTONE 155 PANTONE 5527 PANTONE 5315 PANTONE 4675 PANTONE 4675 PANTONE 9360 PANTONE 4675 PANTONE 401 PANTONE 5155 PANTONE 9183

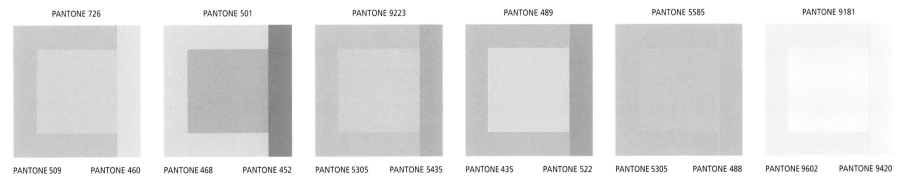

PANTONE 726 PANTONE 501 PANTONE 9223 PANTONE 489 PANTONE 5585 PANTONE 9181

PANTONE 509 PANTONE 460 PANTONE 468 PANTONE 452 PANTONE 5305 PANTONE 5435 PANTONE 435 PANTONE 522 PANTONE 5305 PANTONE 488 PANTONE 9602 PANTONE 9420

Muted

*T*hese palettes are similar in feeling to the preceding

Mellow moods. But the *Muted* tones are a mix of both

warm and cool shades, most often in the mid-tones,

somewhat "grayed-down" and dusky in nature. As they exhibit

this low-key, yet natural complexity, they lend themselves

beautifully to combinations incorporating neutrals such as grays

and taupes.

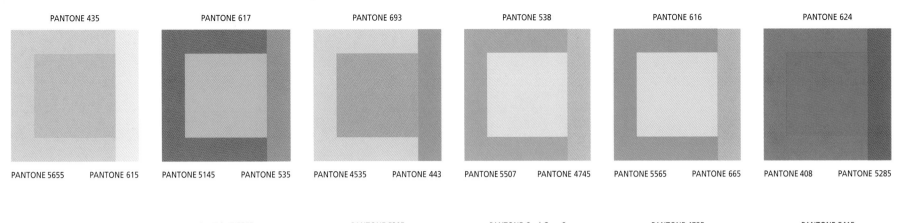

PANTONE 435
PANTONE 5655 PANTONE 615

PANTONE 617
PANTONE 5145 PANTONE 535

PANTONE 693
PANTONE 4535 PANTONE 443

PANTONE 538
PANTONE 5507 PANTONE 4745

PANTONE 616
PANTONE 5565 PANTONE 665

PANTONE 624
PANTONE 408 PANTONE 5285

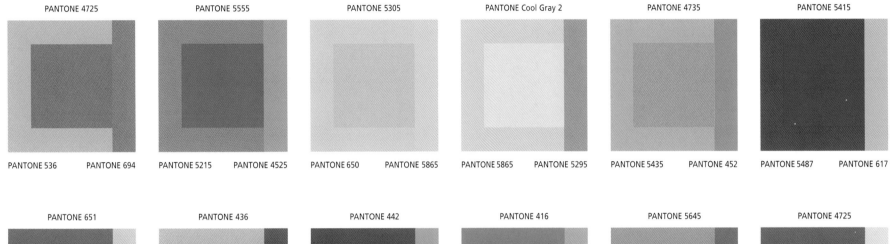

PANTONE 4725
PANTONE 536 PANTONE 694

PANTONE 5555
PANTONE 5215 PANTONE 4525

PANTONE 5305
PANTONE 650 PANTONE 5865

PANTONE Cool Gray 2
PANTONE 5865 PANTONE 5295

PANTONE 4735
PANTONE 5435 PANTONE 452

PANTONE 5415
PANTONE 5487 PANTONE 617

PANTONE 651
PANTONE
Warm Gray 8 PANTONE 5517

PANTONE 436
PANTONE 5025 PANTONE 5625

PANTONE 442
PANTONE 5415 PANTONE 422

PANTONE 416
PANTONE 5497 PANTONE 442

PANTONE 5645
PANTONE 4515 PANTONE 403

PANTONE 4725
PANTONE 5555 PANTONE 441

PANTONE 666
PANTONE 408 PANTONE 623

PANTONE Warm Gray 4
PANTONE 5155 PANTONE 652

PANTONE 5225
PANTONE 480 PANTONE 537

PANTONE 402
PANTONE 5503 PANTONE 4735

PANTONE 623
PANTONE 5855 PANTONE 436

PANTONE 692
PANTONE 5145 PANTONE 557

eclectic intricate diverse unexpected

Capricious

WATERWORKS

These color combinations often evoke a suprise, but it's not as blatant as bright colors would command — it's a subtle, yet unexpected use of color.

74 COLOR COMBINATIONS

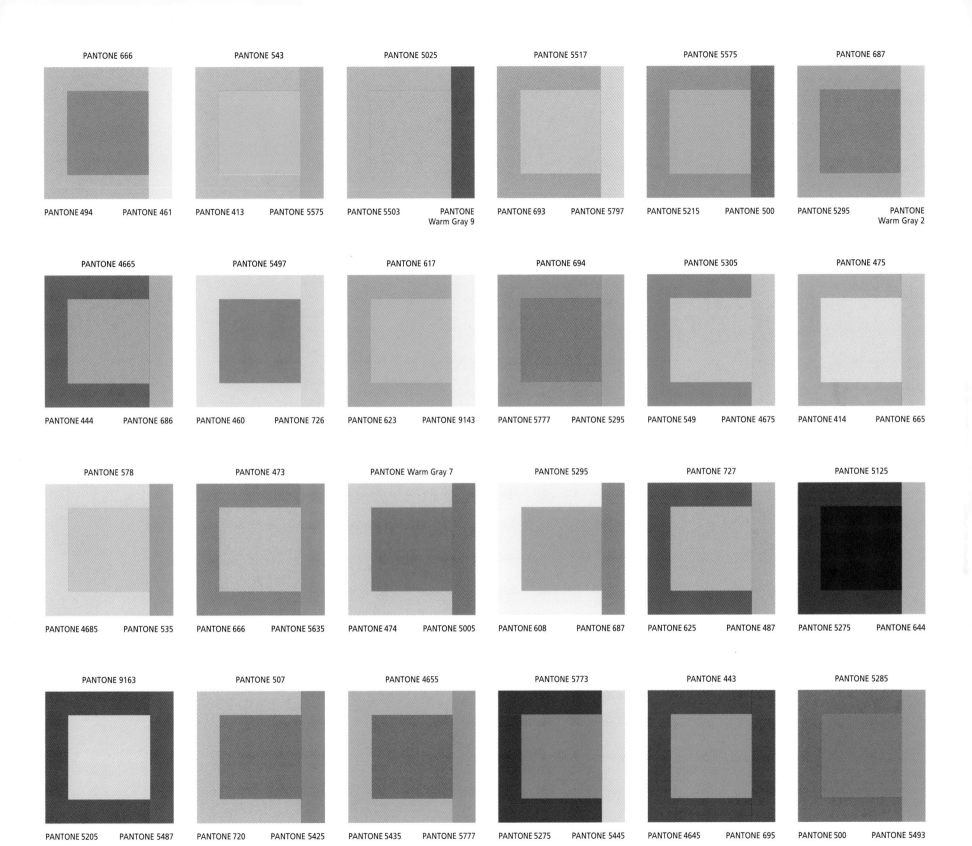

PANTONE 666

PANTONE 494 PANTONE 461

PANTONE 543

PANTONE 413 PANTONE 5575

PANTONE 5025

PANTONE 5503 PANTONE
Warm Gray 9

PANTONE 5517

PANTONE 693 PANTONE 5797

PANTONE 5575

PANTONE 5215 PANTONE 500

PANTONE 687

PANTONE 5295 PANTONE
Warm Gray 2

PANTONE 4665

PANTONE 444 PANTONE 686

PANTONE 5497

PANTONE 460 PANTONE 726

PANTONE 617

PANTONE 623 PANTONE 9143

PANTONE 694

PANTONE 5777 PANTONE 5295

PANTONE 5305

PANTONE 549 PANTONE 4675

PANTONE 475

PANTONE 414 PANTONE 665

PANTONE 578

PANTONE 4685 PANTONE 535

PANTONE 473

PANTONE 666 PANTONE 5635

PANTONE Warm Gray 7

PANTONE 474 PANTONE 5005

PANTONE 5295

PANTONE 608 PANTONE 687

PANTONE 727

PANTONE 625 PANTONE 487

PANTONE 5125

PANTONE 5275 PANTONE 644

PANTONE 9163

PANTONE 5205 PANTONE 5487

PANTONE 507

PANTONE 720 PANTONE 5425

PANTONE 4655

PANTONE 5435 PANTONE 5777

PANTONE 5773

PANTONE 5275 PANTONE 5445

PANTONE 443

PANTONE 4645 PANTONE 695

PANTONE 5285

PANTONE 500 PANTONE 5493

Spiritual

TINA MODOTTI
A LIFE

PINO CACUCCI

TRANSLATED BY PATRICIA J. DUNCAN

SEASHELLS:

IGNORE

ElbowBeach Bermuda
A RAFAEL RESORT

Composed primarily of enigmatic purples, meditative blues, dusky mauves, ghostly grays and wispy whites, this is the thought-provoking, mystical palette that reaches beyond the heavens into other spheres, exploring unknown realms beyond the physical, creating a sense of the surreal.

Carrying too much baggage?

THE INTERFAITH **i** AIRPORT CHAPEL
LOCATED IN THE AIRPORT ATRIUM

*Does anyone really know their
estimated time of departure?*

THE INTERFAITH **i** AIRPORT CHAPEL
LOCATED IN THE AIRPORT ATRIUM

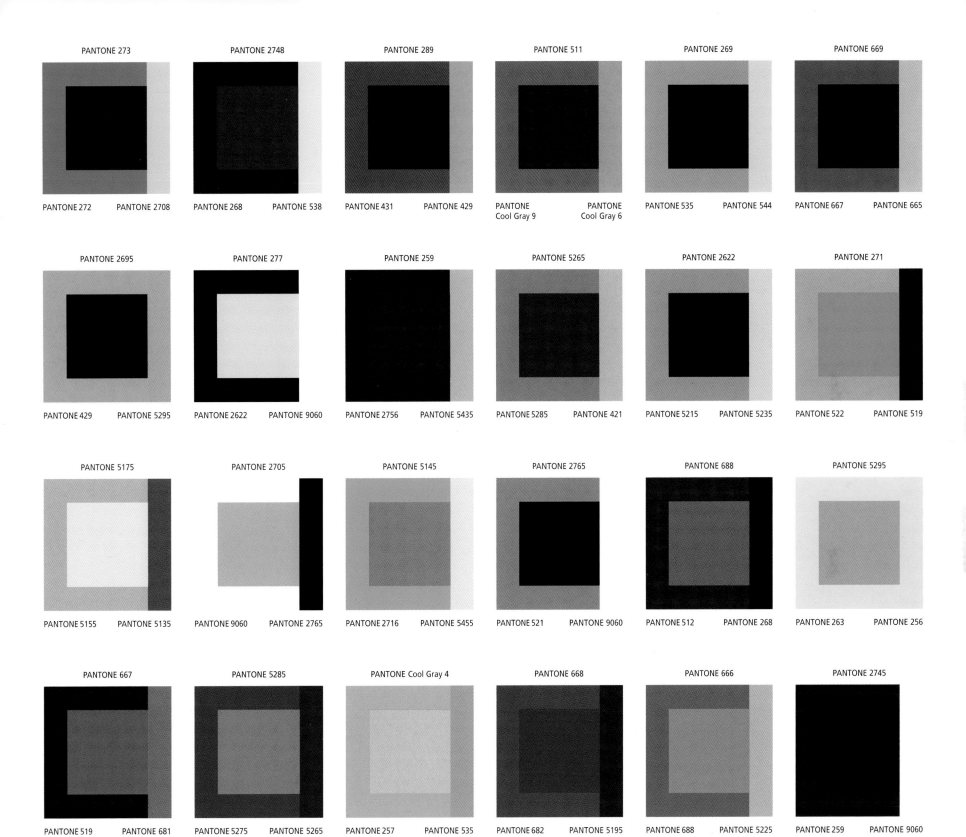

PANTONE 273

PANTONE 272 PANTONE 2708

PANTONE 2748

PANTONE 268 PANTONE 538

PANTONE 289

PANTONE 431 PANTONE 429

PANTONE 511

PANTONE Cool Gray 9 PANTONE Cool Gray 6

PANTONE 269

PANTONE 535 PANTONE 544

PANTONE 669

PANTONE 667 PANTONE 665

PANTONE 2695

PANTONE 429 PANTONE 5295

PANTONE 277

PANTONE 2622 PANTONE 9060

PANTONE 259

PANTONE 2756 PANTONE 5435

PANTONE 5265

PANTONE 5285 PANTONE 421

PANTONE 2622

PANTONE 5215 PANTONE 5235

PANTONE 271

PANTONE 522 PANTONE 519

PANTONE 5175

PANTONE 5155 PANTONE 5135

PANTONE 2705

PANTONE 9060 PANTONE 2765

PANTONE 5145

PANTONE 2716 PANTONE 5455

PANTONE 2765

PANTONE 521 PANTONE 9060

PANTONE 688

PANTONE 512 PANTONE 268

PANTONE 5295

PANTONE 263 PANTONE 256

PANTONE 667

PANTONE 519 PANTONE 681

PANTONE 5285

PANTONE 5275 PANTONE 5265

PANTONE Cool Gray 4

PANTONE 257 PANTONE 535

PANTONE 668

PANTONE 682 PANTONE 5195

PANTONE 666

PANTONE 688 PANTONE 5225

PANTONE 2745

PANTONE 259 PANTONE 9060

Romantic

© Don Paulson

GRASMERE
English Garden Style Floral

0 MAPLE AVE. BARRINGTON, RI
401 247 2789

AN
OCEAN
APART

A NOVEL

ROBIN
PILCHER

Similar to the *Mellow* palette in feeling, the *Romantic* mood embraces many more pink and lavender tones as they are descended from the two most sensual colors, red and purple. But these romantic, light to mid-tone pinks and lavenders are more charming than sexy, far less blatantly sensual than the brighter colors from which they came. Think diffused candlelight, a vase of fragrant roses and dinner for two.

© Gabor Demjen

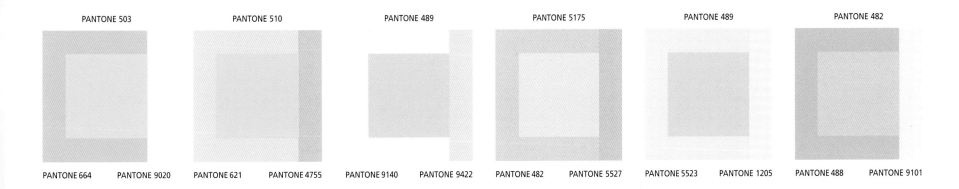

PANTONE 503 · PANTONE 664 · PANTONE 9020
PANTONE 510 · PANTONE 621 · PANTONE 4755
PANTONE 489 · PANTONE 9140 · PANTONE 9422
PANTONE 5175 · PANTONE 482 · PANTONE 5527
PANTONE 489 · PANTONE 5523 · PANTONE 1205
PANTONE 482 · PANTONE 488 · PANTONE 9101

PANTONE 642 · PANTONE 677 · PANTONE 9160
PANTONE 523 · PANTONE 196 · PANTONE 552
PANTONE 5245 · PANTONE 5455 · PANTONE 461
PANTONE 5165 · PANTONE 495 · PANTONE Warm Gray 2
PANTONE 607 · PANTONE 685 · PANTONE 2706
PANTONE 496 · PANTONE 9100 · PANTONE 5585

PANTONE 501 · PANTONE 5245 · PANTONE 607
PANTONE 9060 · PANTONE 5235 · PANTONE 434
PANTONE 509 · PANTONE 2706 · PANTONE 5155
PANTONE 9122 · PANTONE 5015 · PANTONE 622
PANTONE 5025 · PANTONE 536 · PANTONE 5225
PANTONE 5015 · PANTONE 5575 · PANTONE 9061

PANTONE 263 · PANTONE 487 · PANTONE 579
PANTONE 263 · PANTONE 1215 · PANTONE 508
PANTONE 196 · PANTONE 256 · PANTONE 127
PANTONE 502 · PANTONE 460 · PANTONE 670
PANTONE 488 · PANTONE 523 · PANTONE 9021
PANTONE 9183 · PANTONE 9303 · PANTONE 9383

Sensual

his is the tantalizing palette that teases all appetites with its spicy reds, hot purples, succulent oranges, shocking pinks and honeyed dijon shades that may be teamed with a potent black backdrop for added drama. This is not the palette for pales or light tones — they must be dark or bright or a deepened mid-tone. The *Sensual* palette's provocative message is loud and clear — try to resist me!

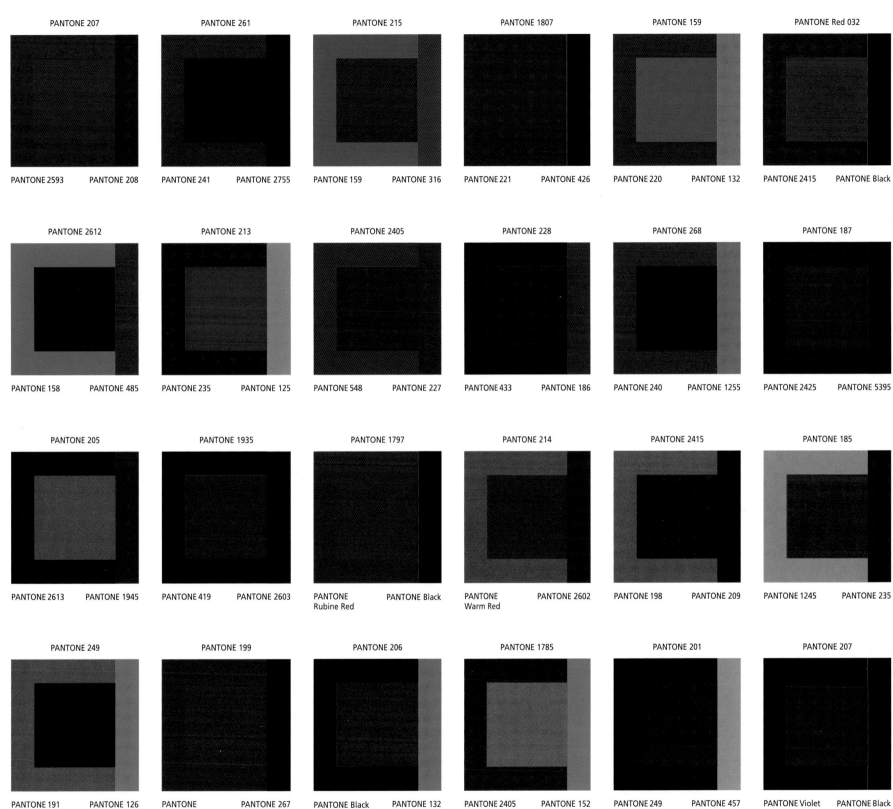

PANTONE 207
PANTONE 2593 PANTONE 208

PANTONE 261
PANTONE 241 PANTONE 2755

PANTONE 215
PANTONE 159 PANTONE 316

PANTONE 1807
PANTONE 221 PANTONE 426

PANTONE 159
PANTONE 220 PANTONE 132

PANTONE Red 032
PANTONE 2415 PANTONE Black

PANTONE 2612
PANTONE 158 PANTONE 485

PANTONE 213
PANTONE 235 PANTONE 125

PANTONE 2405
PANTONE 548 PANTONE 227

PANTONE 228
PANTONE 433 PANTONE 186

PANTONE 268
PANTONE 240 PANTONE 1255

PANTONE 187
PANTONE 2425 PANTONE 5395

PANTONE 205
PANTONE 2613 PANTONE 1945

PANTONE 1935
PANTONE 419 PANTONE 2603

PANTONE 1797
PANTONE Rubine Red PANTONE Black

PANTONE 214
PANTONE Warm Red PANTONE 2602

PANTONE 2415
PANTONE 198 PANTONE 209

PANTONE 185
PANTONE 1245 PANTONE 235

PANTONE 249
PANTONE 191 PANTONE 126

PANTONE 199
PANTONE Process Magenta PANTONE 267

PANTONE 206
PANTONE Black PANTONE 132

PANTONE 1785
PANTONE 2405 PANTONE 152

PANTONE 201
PANTONE 249 PANTONE 457

PANTONE 207
PANTONE Violet PANTONE Black

Powerful

© Don Paulson

This stalwart group contains many mixtures of colors, but the most powerful is the use of one single symbolic hue combined with omnipotent black. Black with scarlet, the ultimate ecclesiastical power color, black with regal purple or royal blue; black with yellow, the eye-riveting color combination of predatory beasts and stinging insects. Additional combinations include variations on black that still speak of authority — rock-solid charcoal gray or deepest blue. And two more power shades from the green family — the color of money and the military.

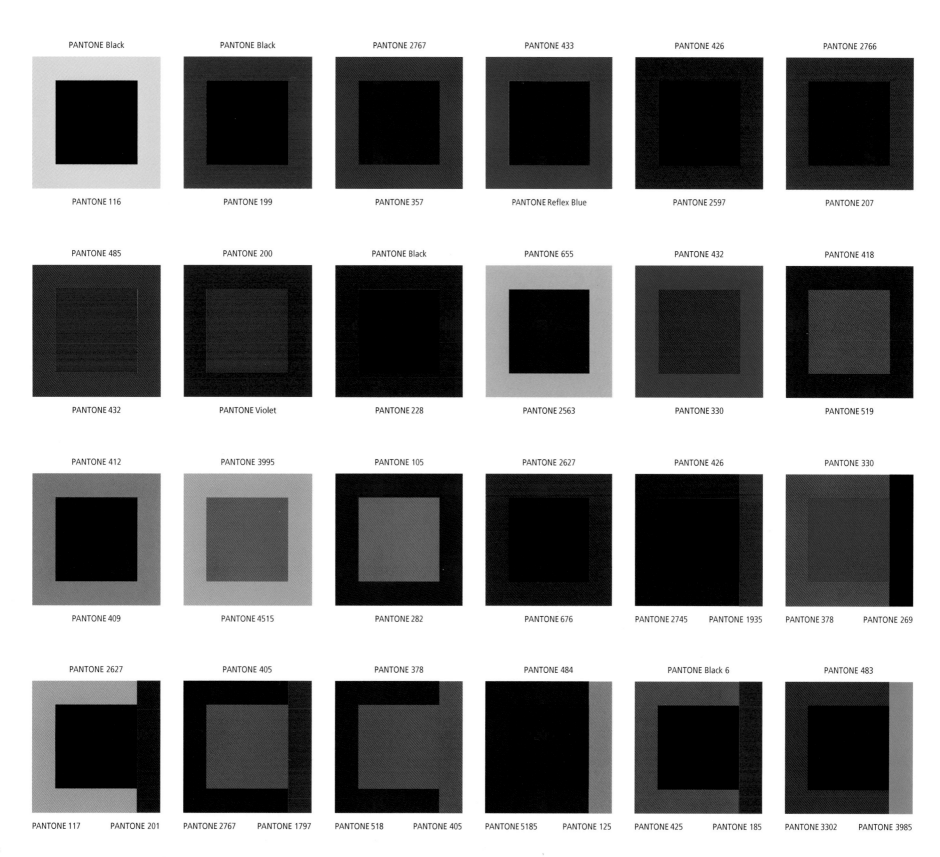

PANTONE Black · PANTONE 116
PANTONE Black · PANTONE 199
PANTONE 2767 · PANTONE 357
PANTONE 433 · PANTONE Reflex Blue
PANTONE 426 · PANTONE 2597
PANTONE 2766 · PANTONE 207

PANTONE 485 · PANTONE 432
PANTONE 200 · PANTONE Violet
PANTONE Black · PANTONE 228
PANTONE 655 · PANTONE 2563
PANTONE 432 · PANTONE 330
PANTONE 418 · PANTONE 519

PANTONE 412 · PANTONE 409
PANTONE 3995 · PANTONE 4515
PANTONE 105 · PANTONE 282
PANTONE 2627 · PANTONE 676
PANTONE 426 · PANTONE 2745 · PANTONE 1935
PANTONE 330 · PANTONE 378 · PANTONE 269

PANTONE 2627 · PANTONE 117 · PANTONE 201
PANTONE 405 · PANTONE 2767 · PANTONE 1797
PANTONE 378 · PANTONE 518 · PANTONE 405
PANTONE 484 · PANTONE 5185 · PANTONE 125
PANTONE Black 6 · PANTONE 425 · PANTONE 185
PANTONE 483 · PANTONE 3302 · PANTONE 3985

Elegant

A bit less mighty than the *Powerful* palette, but no less imposing are the colors symbolic of elegance. Onyx black and other darkened tones are an important presence adding weight and stability, as are neutral grays and subtle taupes. There are amethysts and aubergines, deep peridot, emerald and malachite greens, sapphire blues, cashmere grays, mink browns and ruby reds. And for a more obvious opulence, metallic golds, silvers, bronzes and coppers may be used for contrast.

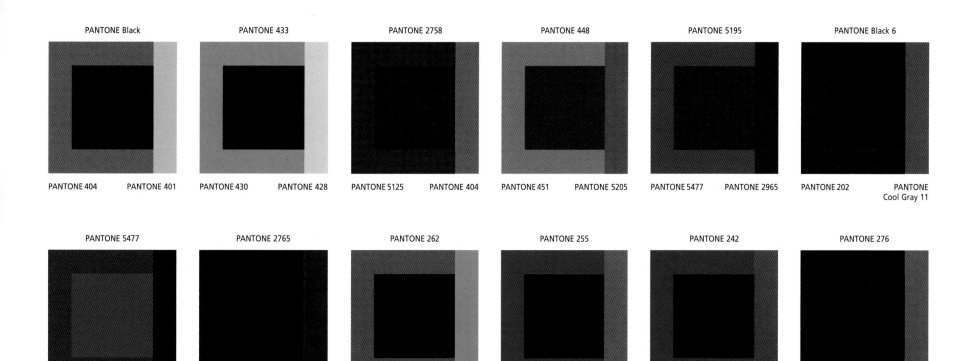

PANTONE Black	PANTONE 433	PANTONE 2758	PANTONE 448	PANTONE 5195	PANTONE Black 6
PANTONE 404 PANTONE 401	PANTONE 430 PANTONE 428	PANTONE 5125 PANTONE 404	PANTONE 451 PANTONE 5205	PANTONE 5477 PANTONE 2965	PANTONE 202 PANTONE Cool Gray 11

PANTONE 5477	PANTONE 2765	PANTONE 262	PANTONE 255	PANTONE 242	PANTONE 276
PANTONE 449 PANTONE 229	PANTONE 209 PANTONE 439	PANTONE Warm Gray 10 PANTONE Warm Gray 7	PANTONE 309 PANTONE 3995	PANTONE 5275 PANTONE Cool Gray 11	PANTONE 2627 PANTONE Cool Gray 10

PANTONE 229	PANTONE 3308	PANTONE 412	PANTONE 269	PANTONE 2623	PANTONE 2622
PANTONE 4485 PANTONE 4505	PANTONE 1545 PANTONE Warm Gray 9	PANTONE 5747 PANTONE 512	PANTONE 161 PANTONE 3995	PANTONE 464 PANTONE 450	PANTONE Warm Gray 11 PANTONE 4985

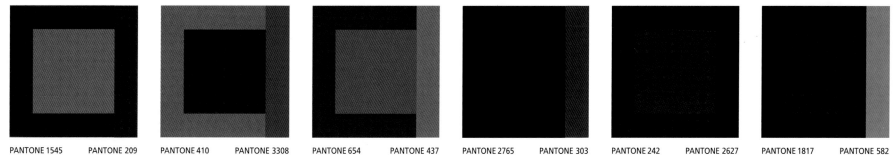

PANTONE 5825	PANTONE 222	PANTONE 5615	PANTONE 262	PANTONE 1955	PANTONE 216
PANTONE 1545 PANTONE 209	PANTONE 410 PANTONE 3308	PANTONE 654 PANTONE 437	PANTONE 2765 PANTONE 303	PANTONE 242 PANTONE 2627	PANTONE 1817 PANTONE 582

Robust

A more sophisticated and less rustic version of the earth tones, this *Robust* palette is literally about taste. The colors are both tasty and tasteful: rich chocolate browns, full-bodied merlots, burgundy and claret wines, sparkling sauterne and chardonnay, plum purples, berry reds all juxtaposed against vineyard greens... a tempting visual feast.

PANTONE 476 PANTONE 207 PANTONE 276 PANTONE 2425 PANTONE 5815 PANTONE 5195

PANTONE 249 PANTONE 194 PANTONE 505 PANTONE 464 PANTONE 1955 PANTONE 260 PANTONE 118 PANTONE 477 PANTONE 229 PANTONE 1685 PANTONE 492 PANTONE 464

PANTONE 188 PANTONE 462 PANTONE 4705 PANTONE 690 PANTONE 188 PANTONE 160

PANTONE 5615 PANTONE 161 PANTONE 5125 PANTONE 484 PANTONE 1805 PANTONE 553 PANTONE 5825 PANTONE 2745 PANTONE 5743 PANTONE 439 PANTONE 697 PANTONE 117

PANTONE 5615 PANTONE 506 PANTONE 469 PANTONE 371 PANTONE 3302 PANTONE 221

PANTONE 4705 PANTONE 703 PANTONE 111 PANTONE 668 PANTONE 1807 PANTONE 3995 PANTONE 490 PANTONE 683 PANTONE 242 PANTONE 1615 PANTONE 275 PANTONE 125

PANTONE 554 PANTONE 1945 PANTONE 5265 PANTONE 208 PANTONE 4705 PANTONE 4485

PANTONE 195 PANTONE 255 PANTONE 181 PANTONE 3308 PANTONE 4635 PANTONE 682 PANTONE 1245 PANTONE 464 PANTONE 209 PANTONE 262 PANTONE 269 PANTONE 704

Delicate

© Don Paulson

ROSEMARY
KAY

S A U L

A NOVEL

The lightest and most fragile of all of the palettes are the delicate pastels. A balanced mixture of both warm and cool colors, these tender tines are the easiest of all the palettes to combine. Their pale colorations happily co-exist and always blend beautifully with tinted whites or lightened neutrals. More than any other palette, they express vulnerability and fragility.

PANTONE 9120 PANTONE 9200 PANTONE 9141 PANTONE 9480 PANTONE 9400 PANTONE 9582

PANTONE 9260 PANTONE 9460 PANTONE 9600 PANTONE 9340 PANTONE 9401 PANTONE 9201 PANTONE 9042 PANTONE 9342 PANTONE 9220 PANTONE 9142 PANTONE 9382 PANTONE 9240

PANTONE 9440 PANTONE 9300 PANTONE 9181 PANTONE 9120 PANTONE 9402 PANTONE 9140

PANTONE 9142 PANTONE 9580 PANTONE 9160 PANTONE 9043 PANTONE 9341 PANTONE 9143 PANTONE 9381 PANTONE 9560 PANTONE 9581 PANTONE 9143 PANTONE 9420 PANTONE 9241

PANTONE 9380 PANTONE 9540 PANTONE 9600 PANTONE 9360 PANTONE 9061 PANTONE 9421

PANTONE 9180 PANTONE 9020 PANTONE 9403 PANTONE 9122 PANTONE 9403 PANTONE 9060 PANTONE 9400 PANTONE 9060 PANTONE 9481 PANTONE 9300 PANTONE 9360 PANTONE 9062

PANTONE 9383 PANTONE 9280 PANTONE 9400 PANTONE 9540 PANTONE 9561 PANTONE 9600

PANTONE 9140 PANTONE 9200 PANTONE 9541 PANTONE 9020 PANTONE 9281 PANTONE 9580 PANTONE 9020 PANTONE 9201 PANTONE 9022 PANTONE 9480 PANTONE 9242 PANTONE 9060

Playful

© Laura Paresky

*A*s uninhibited as the kids who love them, these extroverted brights are for the kids within all of us. A mix of vibrant warms and cools from every color family, their intense vitality expresses movement, activity, exuberance and above all, unrestrained joy.

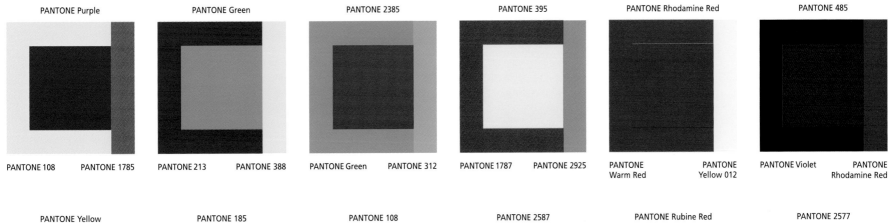

PANTONE Purple	PANTONE Green	PANTONE 2385	PANTONE 395	PANTONE Rhodamine Red	PANTONE 485

PANTONE 108 · PANTONE 1785 | PANTONE 213 · PANTONE 388 | PANTONE Green · PANTONE 312 | PANTONE 1787 · PANTONE 2925 | PANTONE Warm Red · PANTONE Yellow 012 | PANTONE Violet · PANTONE Rhodamine Red

PANTONE Yellow
PANTONE Orange 021 — PANTONE Process Blue

PANTONE 185
PANTONE Purple — PANTONE Reflex Blue

PANTONE 108
PANTONE 2725 — PANTONE 307

PANTONE 2587
PANTONE 219 — PANTONE 326

PANTONE Rubine Red
PANTONE 300 — PANTONE 361

PANTONE 2577
PANTONE 108 — PANTONE 383

PANTONE 360
PANTONE 205 — PANTONE 528

PANTONE Orange 021
PANTONE Yellow 012 — PANTONE 388

PANTONE Process Magenta
PANTONE Process Cyan — PANTONE 381

PANTONE Process Magenta
PANTONE Process Yellow — PANTONE Process Cyan

PANTONE 213
PANTONE Purple — PANTONE 2727

PANTONE 109
PANTONE 219 — PANTONE 2582

PANTONE Process Magenta
PANTONE Orange 021 — PANTONE Process Yellow

PANTONE Process Blue
PANTONE 388 — PANTONE Violet

PANTONE Violet
PANTONE Yellow 012 — PANTONE 213

PANTONE 676
PANTONE 1585 — PANTONE 285

PANTONE 313
PANTONE 151 — PANTONE 212

PANTONE 2935
PANTONE 390 — PANTONE 2395

Energetic

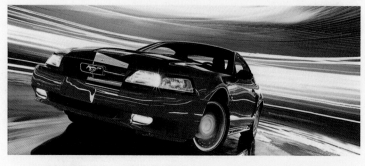

Similar in mood to the *Playful* palette, this group of combinations is a bit more grown-up, but no less active. The intensity of the activity level is best expressed by combinations of predominantly warm vivid colors. Backgrounds of black or other deepened mid-tones or darks can add to the drama and excitement, while a whitened background can lighten the mood.

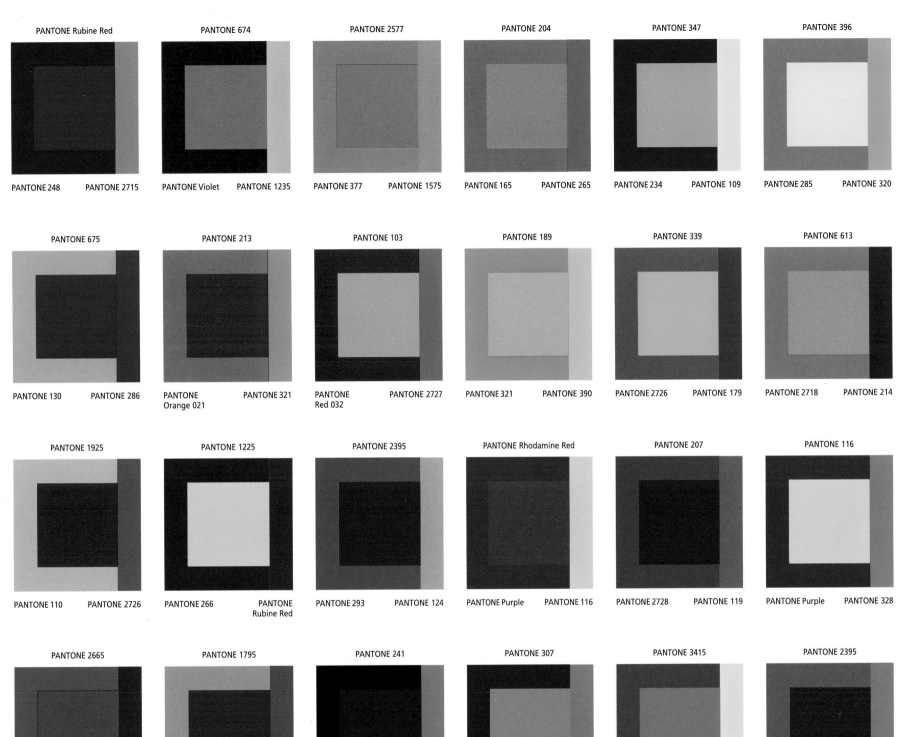

PANTONE Rubine Red PANTONE 674 PANTONE 2577 PANTONE 204 PANTONE 347 PANTONE 396

PANTONE 248 PANTONE 2715 PANTONE Violet PANTONE 1235 PANTONE 377 PANTONE 1575 PANTONE 165 PANTONE 265 PANTONE 234 PANTONE 109 PANTONE 285 PANTONE 320

PANTONE 675 PANTONE 213 PANTONE 103 PANTONE 189 PANTONE 339 PANTONE 613

PANTONE 130 PANTONE 286 PANTONE Orange 021 PANTONE 321 PANTONE Red 032 PANTONE 2727 PANTONE 321 PANTONE 390 PANTONE 2726 PANTONE 179 PANTONE 2718 PANTONE 214

PANTONE 1925 PANTONE 1225 PANTONE 2395 PANTONE Rhodamine Red PANTONE 207 PANTONE 116

PANTONE 110 PANTONE 2726 PANTONE 266 PANTONE Rubine Red PANTONE 293 PANTONE 124 PANTONE Purple PANTONE 116 PANTONE 2728 PANTONE 119 PANTONE Purple PANTONE 328

PANTONE 2665 PANTONE 1795 PANTONE 241 PANTONE 307 PANTONE 3415 PANTONE 2395

PANTONE 166 PANTONE Rubine Red PANTONE 104 PANTONE 258 PANTONE Violet PANTONE 322 PANTONE 253 PANTONE 138 PANTONE 2587 PANTONE 109 PANTONE 2725 PANTONE 300

Traditional

This palette is similar to both the *Elegant* and *Powerful* palettes, but leans less heavily on black choosing instead less formidable navy and colonial blue, hunter green, burgundy red, cranberry, plum, amber gold, mid to deep gray, taupe and mahogany. These are historically significant hues with a sense of connectedness. If metallics are used here for accent or contrast, they are subtle pewters and burnished gold.

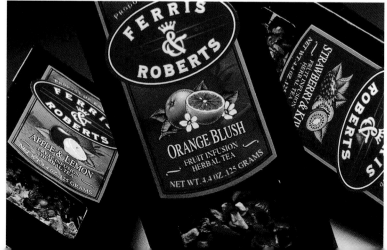

PANTONE 5605	PANTONE 418	PANTONE 560	PANTONE 202	PANTONE 357	PANTONE 2768
PANTONE 478 / PANTONE 534	PANTONE 5255 / PANTONE 423	PANTONE 411 / PANTONE 202	PANTONE 5115 / PANTONE 462	PANTONE 289 / PANTONE 216	PANTONE 518 / PANTONE 445
PANTONE 3435	PANTONE 690	PANTONE Warm Gray 8	PANTONE 147	PANTONE 5463	PANTONE 5415
PANTONE 1265 / PANTONE 195	PANTONE 4625 / PANTONE 3035	PANTONE 2965 / PANTONE 4695	PANTONE 432 / PANTONE 417	PANTONE 5405 / PANTONE Warm Gray 5	PANTONE 269 / PANTONE 2767
PANTONE 415	PANTONE 296	PANTONE 648	PANTONE 2695	PANTONE 437	PANTONE 5535
PANTONE 547 / PANTONE 2766	PANTONE 209 / PANTONE 350	PANTONE 432 / PANTONE 511	PANTONE 440 / PANTONE 5463	PANTONE 1405 / PANTONE 1817	PANTONE 1955 / PANTONE 449
PANTONE 5467	PANTONE 296	PANTONE 133	PANTONE 648	PANTONE 533	PANTONE 2695
PANTONE 455 / PANTONE 4625	PANTONE 216 / PANTONE 1255	PANTONE 627 / PANTONE 1245	PANTONE 620 / PANTONE 5115	PANTONE 483 / PANTONE Warm Gray 11	PANTONE 188 / PANTONE 626

Classic

© Don Paulson

JUDAH L.
MAGNES
MUSEUM

THE JEWISH MUSEUM
OF THE WEST
BERKELEY
CALIFORNIA

ELISABETH
ANDERSEN

(DRESSES)

The most elemental and non-changing of all color combinations are the classics: the many nuances of those elements that are ever-present in nature — of pebbles, rocks, stones, caverns and caves. They symbolize the antiquity of weathered buildings and ancient monuments, sand and sphinx. These are neutral tones that go beyond the simplest beiges, grays and taupes into the barely perceptual mineral shades, yet at the same time, include the most basic of all combinations, the fundamental simplicity of black and white.

© Don Paulson

MASQUERADE

WALTER SATTERTHWAIT

PANTONE 4545

PANTONE 4525 PANTONE 445

PANTONE 468

PANTONE
Warm Gray 6 PANTONE
 Black 7

PANTONE 467

PANTONE PANTONE 9140
Warm Gray 4

PANTONE Cool Gray 1

PANTONE PANTONE
Cool Gray 3 Cool Gray 5

PANTONE Warm Gray 1

PANTONE PANTONE
Warm Gray 3 Warm Gray 5

PANTONE 443

PANTONE 444 PANTONE 447

PANTONE 5507

PANTONE 5487 PANTONE 5477

PANTONE 419

PANTONE 417 PANTONE 415

PANTONE 453

PANTONE 451 PANTONE 450

PANTONE 5445

PANTONE 5425 PANTONE 5395

PANTONE Cool Gray 7

PANTONE PANTONE
Cool Gray 9 Cool Gray 11

PANTONE Warm Gray 7

PANTONE PANTONE
Warm Gray 9 Warm Gray 11

PANTONE Cool Gray 6

PANTONE PANTONE
Cool Gray 8 Cool Gray 10

PANTONE 435

PANTONE 437 PANTONE 438

PANTONE 428

PANTONE 429 PANTONE 431

PANTONE 411

PANTONE 409 PANTONE 407

PANTONE 441

PANTONE 443 PANTONE 446

PANTONE 454

PANTONE 452 PANTONE 450

PANTONE Warm Gray 6

PANTONE 9142 PANTONE Black

PANTONE Black

PANTONE 452 PANTONE
 Cool Gray 7

PANTONE Warm Gray 4

PANTONE 430 PANTONE Black

PANTONE Black

PANTONE 9060 PANTONE
 Cool Gray 11

PANTONE Warm Gray 5

PANTONE 9060 PANTONE 276

PANTONE 429

PANTONE 9060 PANTONE 432

Festive

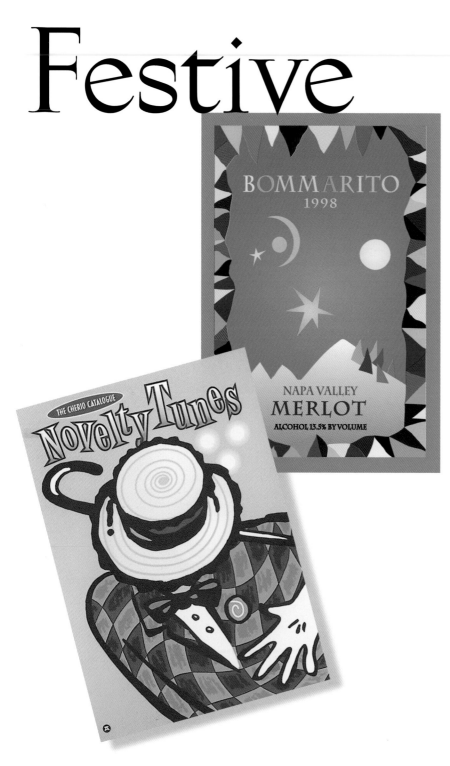

*T*his dancing kaleidoscope of color is more complex than the predominantly primary brights of the *Playful* palette. They are often punctuated with deeper accents for added contrast. Just as if a bag of confetti had been thrown into the air and landed randomly, the combinations display a free and open choice of color depicting a sense of movement and exhilaration.

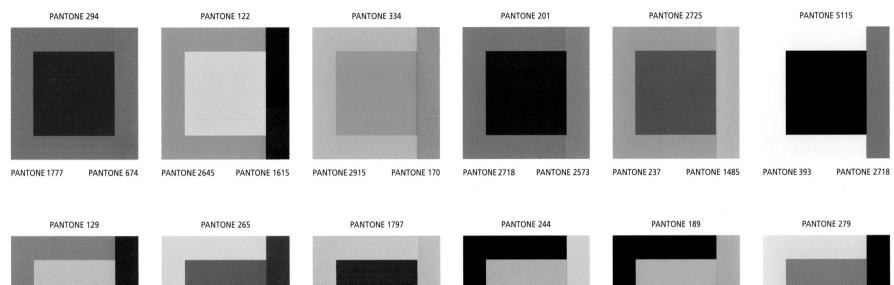

PANTONE 294

PANTONE 122

PANTONE 334

PANTONE 201

PANTONE 2725

PANTONE 5115

| PANTONE 1777 | PANTONE 674 | PANTONE 2645 | PANTONE 1615 | PANTONE 2915 | PANTONE 170 | PANTONE 2718 | PANTONE 2573 | PANTONE 237 | PANTONE 1485 | PANTONE 393 | PANTONE 2718 |

PANTONE 129

PANTONE 265

PANTONE 1797

PANTONE 244

PANTONE 189

PANTONE 279

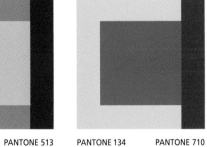

| PANTONE 190 | PANTONE 513 | PANTONE 134 | PANTONE 710 | PANTONE 1225 | PANTONE 530 | PANTONE 228 | PANTONE 1355 | PANTONE 181 | PANTONE 2705 | PANTONE 610 | PANTONE 295 |

PANTONE 288

PANTONE 163

PANTONE 2718

PANTONE 2715

PANTONE 264

PANTONE 709

| PANTONE 264 | PANTONE 1765 | PANTONE 526 | PANTONE 292 | PANTONE 157 | PANTONE 115 | PANTONE 711 | PANTONE 249 | PANTONE 3395 | PANTONE 674 | PANTONE 3415 | PANTONE 379 |

PANTONE 284

PANTONE 1775

PANTONE 2563

PANTONE 1817

PANTONE 223

PANTONE 142

| PANTONE 120 | PANTONE 710 | PANTONE 515 | PANTONE 2718 | PANTONE 255 | PANTONE 1555 | PANTONE 609 | PANTONE 673 | PANTONE 2715 | PANTONE 1365 | PANTONE 2718 | PANTONE 676 |

Fanciful

*A*s tempting as a dish of jelly beans, the *Fanciful* colors are not quite as intense as the other bright palettes, yet this potpourri of lively combinations still commands more attention and displays more personality than softer spoken light to mid-tones.

If contrast is needed, the neutral off-whites and cream colors are best as they will not distract from the vibrancy of these happy colors.

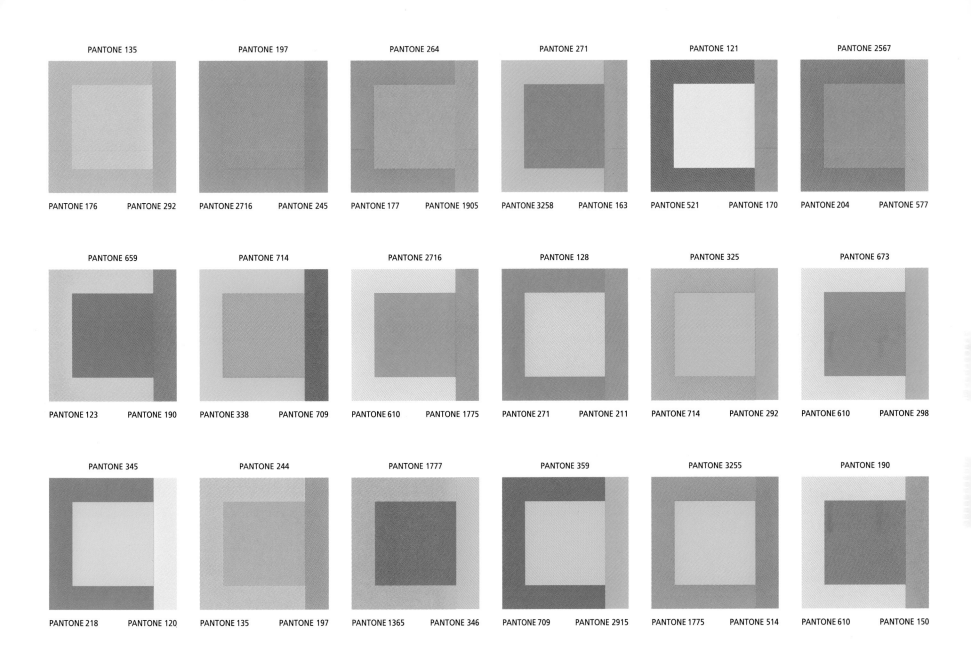

PANTONE 135

PANTONE 176 PANTONE 292

PANTONE 197

PANTONE 2716 PANTONE 245

PANTONE 264

PANTONE 177 PANTONE 1905

PANTONE 271

PANTONE 3258 PANTONE 163

PANTONE 121

PANTONE 521 PANTONE 170

PANTONE 2567

PANTONE 204 PANTONE 577

PANTONE 659

PANTONE 123 PANTONE 190

PANTONE 714

PANTONE 338 PANTONE 709

PANTONE 2716

PANTONE 610 PANTONE 1775

PANTONE 128

PANTONE 271 PANTONE 211

PANTONE 325

PANTONE 714 PANTONE 292

PANTONE 673

PANTONE 610 PANTONE 298

PANTONE 345

PANTONE 218 PANTONE 120

PANTONE 244

PANTONE 135 PANTONE 197

PANTONE 1777

PANTONE 1365 PANTONE 346

PANTONE 359

PANTONE 709 PANTONE 2915

PANTONE 3255

PANTONE 1775 PANTONE 514

PANTONE 190

PANTONE 610 PANTONE 150

PANTONE 585

PANTONE 310 PANTONE 177

PANTONE 709

PANTONE 577 PANTONE 271

PANTONE 630

PANTONE 177 PANTONE 603

PANTONE 659

PANTONE 577 PANTONE 184

PANTONE 284

PANTONE 211 PANTONE 2573

PANTONE 270

PANTONE 128 PANTONE 673

Cool

This palette is mindful of those activities that refresh and replenish — a splash of cool water, a breath of fresh air, the utter exhilaration of diving into a cool pool on a hot summer day, the taste of mint. The colors are found on the cool side of the spectrum, primarily clean and clear, with a hint of warmth in the seafoam greens. This is the perfect spot for snow white, but it should be pure, crystalline and sparkling bright.

© Don Paulson

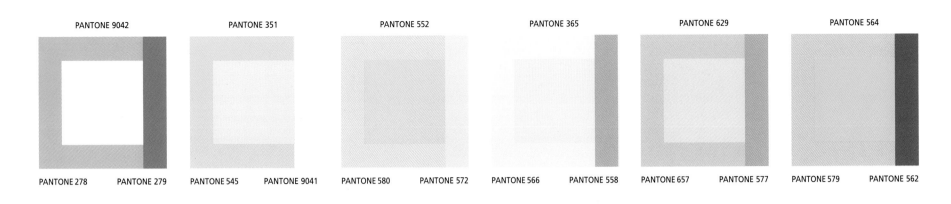

PANTONE 9042	PANTONE 351	PANTONE 552	PANTONE 365	PANTONE 629	PANTONE 564
PANTONE 278 PANTONE 279	PANTONE 545 PANTONE 9041	PANTONE 580 PANTONE 572	PANTONE 566 PANTONE 558	PANTONE 657 PANTONE 577	PANTONE 579 PANTONE 562

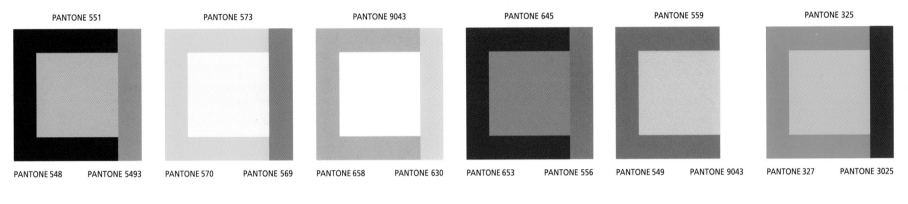

PANTONE 551	PANTONE 573	PANTONE 9043	PANTONE 645	PANTONE 559	PANTONE 325
PANTONE 548 PANTONE 5493	PANTONE 570 PANTONE 569	PANTONE 658 PANTONE 630	PANTONE 653 PANTONE 556	PANTONE 549 PANTONE 9043	PANTONE 327 PANTONE 3025

PANTONE 543	PANTONE 9040	PANTONE 631	PANTONE 9042	PANTONE 333	PANTONE 3375
PANTONE 338 PANTONE 359	PANTONE 324 PANTONE 2945	PANTONE 2915 PANTONE 365	PANTONE 305 PANTONE 279	PANTONE 358 PANTONE 647	PANTONE 2985 PANTONE 659

PANTONE 542	PANTONE 9062	PANTONE 285	PANTONE 304	PANTONE 563	PANTONE 543
PANTONE 3258 PANTONE 580	PANTONE 352 PANTONE 335	PANTONE 3105 PANTONE 353	PANTONE 283 PANTONE 9063	PANTONE 308 PANTONE 579	PANTONE 9040 PANTONE 571

Warm

Yves Delorme®
PARIS
for
Palais Royal

NG. BEAUTIFULLY

nens for Bed, Bath & Table

Applique Yellow

sundance

Stewart,
Tabori
& Chang

*W*arm combinations instantly evoke a comfort
level related to sunshine. Although we may
not see the sun in symbolic yellow, its warm inviting
presence is always felt. Whites are always creamy and the golden
undertones in the combinations
suggest an easygoing, non-invasive
mood, similar in feeling to the
Mellow palette, but even warmer.

Tangerines in the winter on the sill

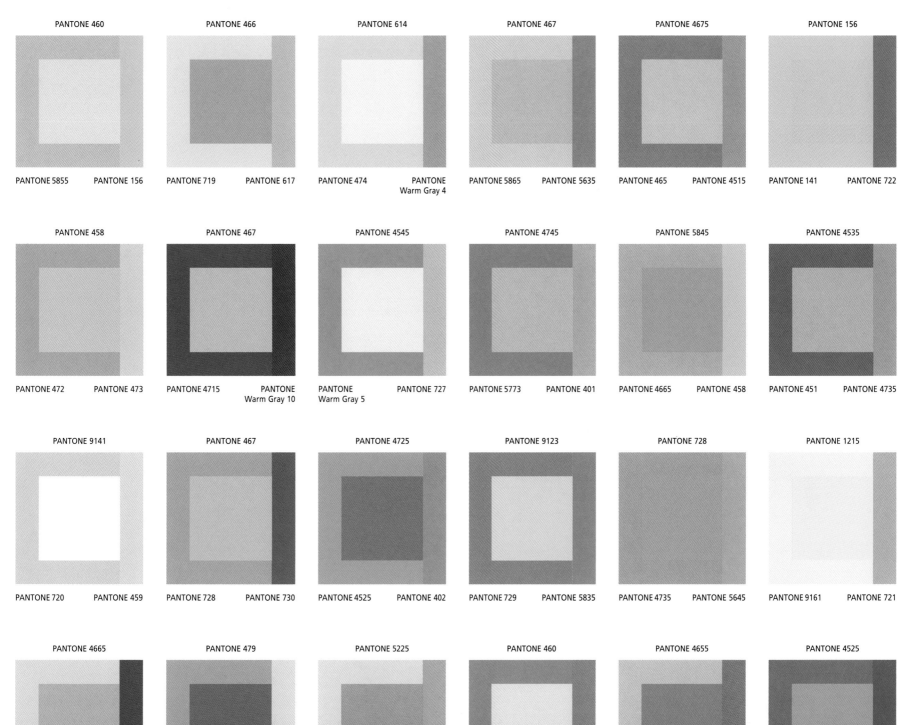

PANTONE 460

PANTONE 5855 PANTONE 156

PANTONE 466

PANTONE 719 PANTONE 617

PANTONE 614

PANTONE 474 PANTONE
Warm Gray 4

PANTONE 467

PANTONE 5865 PANTONE 5635

PANTONE 4675

PANTONE 465 PANTONE 4515

PANTONE 156

PANTONE 141 PANTONE 722

PANTONE 458

PANTONE 472 PANTONE 473

PANTONE 467

PANTONE 4715 PANTONE
Warm Gray 10

PANTONE 4545

PANTONE
Warm Gray 5 PANTONE 727

PANTONE 4745

PANTONE 5773 PANTONE 401

PANTONE 5845

PANTONE 4665 PANTONE 458

PANTONE 4535

PANTONE 451 PANTONE 4735

PANTONE 9141

PANTONE 720 PANTONE 459

PANTONE 467

PANTONE 728 PANTONE 730

PANTONE 4725

PANTONE 4525 PANTONE 402

PANTONE 9123

PANTONE 729 PANTONE 5835

PANTONE 728

PANTONE 4735 PANTONE 5645

PANTONE 1215

PANTONE 9161 PANTONE 721

PANTONE 4665

PANTONE 459 PANTONE 4715

PANTONE 479

PANTONE 480 PANTONE 616

PANTONE 5225

PANTONE 454 PANTONE 472

PANTONE 460

PANTONE
Warm Gray 6 PANTONE 465

PANTONE 4655

PANTONE 5793 PANTONE 5215

PANTONE 4525

PANTONE 403 PANTONE 4645

Luscious & Sweet

This mouth-watering melange includes the confectionary colors that are always thought of as sweet to the taste as well as to the eye. Think smoothies and sherbets; delectable ice cream, creamy gelatos, lattes with mocha, decadent chocolate and hot fudge sundaes with whipped cream and a cherry on top. Think strawberry, blueberry, raspberry and banana creme. Think pink lemonade and peach melba. The mixes are luscious and so are the color possibilities.

© Gabor Demjen

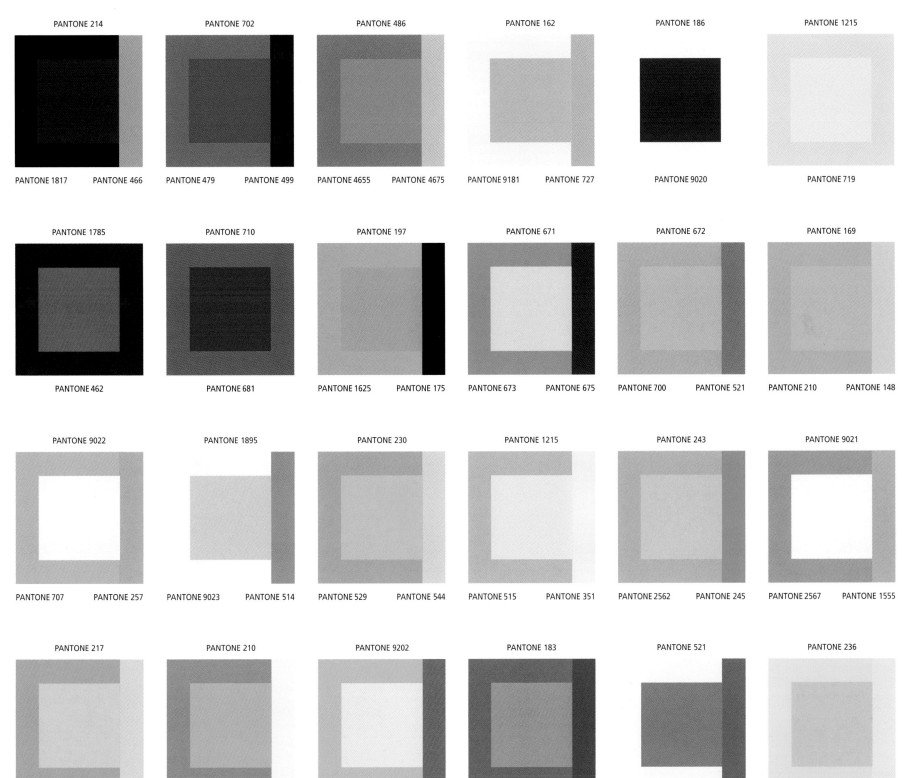

PANTONE 214 PANTONE 702 PANTONE 486 PANTONE 162 PANTONE 186 PANTONE 1215

PANTONE 1817 PANTONE 466 PANTONE 479 PANTONE 499 PANTONE 4655 PANTONE 4675 PANTONE 9181 PANTONE 727 PANTONE 9020 PANTONE 719

PANTONE 1785 PANTONE 710 PANTONE 197 PANTONE 671 PANTONE 672 PANTONE 169

PANTONE 462 PANTONE 681 PANTONE 1625 PANTONE 175 PANTONE 673 PANTONE 675 PANTONE 700 PANTONE 521 PANTONE 210 PANTONE 148

PANTONE 9022 PANTONE 1895 PANTONE 230 PANTONE 1215 PANTONE 243 PANTONE 9021

PANTONE 707 PANTONE 257 PANTONE 9023 PANTONE 514 PANTONE 529 PANTONE 544 PANTONE 515 PANTONE 351 PANTONE 2562 PANTONE 245 PANTONE 2567 PANTONE 1555

PANTONE 217 PANTONE 210 PANTONE 9202 PANTONE 183 PANTONE 521 PANTONE 236

PANTONE 1905 PANTONE 134 PANTONE 177 PANTONE 9182 PANTONE 203 PANTONE 212 PANTONE 184 PANTONE 4995 PANTONE 9100 PANTONE 479 PANTONE 352 PANTONE 545

Spicy· *hot*

Tangy *tart*

*W*hen the temperature is hot and spicy (especially to the tongue), the colors must turn up the heat. This palette demands curried yellows, vibrant oranges, and the purples are on the fiery side. There are vivid salsa and chili pepper reds, a dash of cayenne with a side of cilantro or guacamole green. To quell the fire, you might splash on a little cool color — but very little.

Tangy/Tart is suggested by the fruit flavors that are inevitably connected with the tastes of lemon, lime, orange, kiwi and pomegranate. Pink grapefruit adds more dimension to the mixes. Unlike the *Luscious/Sweet* palette, there's a sugary bite to this whimsical group of Life Saver colors.

PANTONE 612	PANTONE 613	PANTONE 1235	PANTONE Orange 021	PANTONE 1225	PANTONE 360
PANTONE 193 · PANTONE 1235	PANTONE 716 · PANTONE 2587	PANTONE 1788 · PANTONE 605	PANTONE 583 · PANTONE 604	PANTONE 1505 · PANTONE 611	PANTONE 606 · PANTONE 184
PANTONE Warm Red	PANTONE 180	PANTONE 1788	PANTONE 383	PANTONE 3955	PANTONE 103
PANTONE 2592 · PANTONE 104	PANTONE 130 · PANTONE 258	PANTONE 606 · PANTONE 385	PANTONE 151 · PANTONE 386	PANTONE 1777 · PANTONE 368	PANTONE 361 · PANTONE 108
PANTONE 131	PANTONE 151	PANTONE 370	PANTONE 1785	PANTONE 116	PANTONE 1585
PANTONE 1795 · PANTONE 265	PANTONE 130 · PANTONE 180	PANTONE Orange 021 · PANTONE 527	PANTONE 382 · PANTONE 1505	PANTONE 104 · PANTONE 363	PANTONE 584 · PANTONE 1777
PANTONE 2583	PANTONE Warm Red	PANTONE 137	PANTONE 369	PANTONE 107	PANTONE 362
PANTONE 1807 · PANTONE 1788	PANTONE 131 · PANTONE 612	PANTONE 179 · PANTONE 363	PANTONE 172 · PANTONE 3965	PANTONE 1787 · PANTONE 375	PANTONE 394 · PANTONE Warm Red

Unique 1

From the extraordinary to the bizarre, when the situation calls for a really unique combination or an element of surprise, nothing gives the non-verbal message better than color. Some of the following combinations are more subtly unusual rather than shocking, while some may be considered eccentric or odd. What is provocative and pleasing to one pair of eyes may be completely outrageous to another. But they do cause attention and in many instances, that's the whole point!

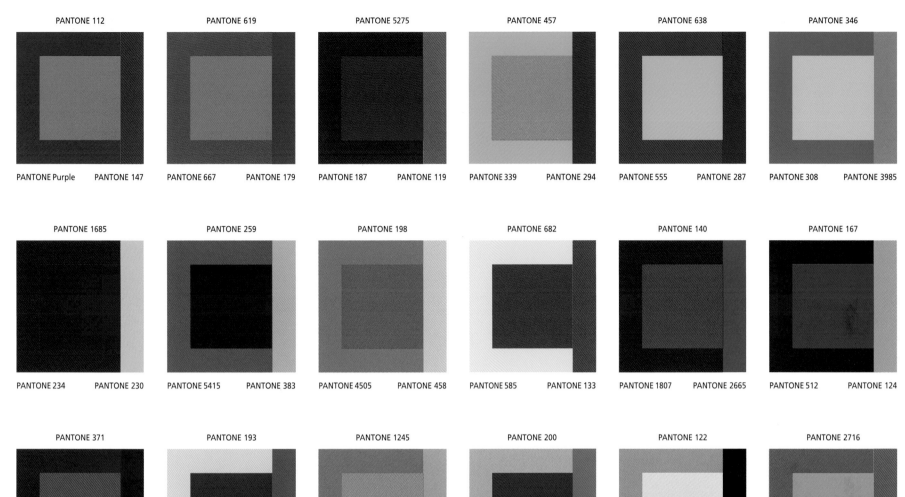

PANTONE 112	PANTONE 619	PANTONE 5275	PANTONE 457	PANTONE 638	PANTONE 346
PANTONE Purple — PANTONE 147	PANTONE 667 — PANTONE 179	PANTONE 187 — PANTONE 119	PANTONE 339 — PANTONE 294	PANTONE 555 — PANTONE 287	PANTONE 308 — PANTONE 3985
PANTONE 1685	PANTONE 259	PANTONE 198	PANTONE 682	PANTONE 140	PANTONE 167
PANTONE 234 — PANTONE 230	PANTONE 5415 — PANTONE 383	PANTONE 4505 — PANTONE 458	PANTONE 585 — PANTONE 133	PANTONE 1807 — PANTONE 2665	PANTONE 512 — PANTONE 124
PANTONE 371	PANTONE 193	PANTONE 1245	PANTONE 200	PANTONE 122	PANTONE 2716
PANTONE 234 — PANTONE 732	PANTONE 611 — PANTONE 301	PANTONE 184 — PANTONE 2716	PANTONE 257 — PANTONE 322	PANTONE 514 — PANTONE 229	PANTONE 723 — PANTONE 5757
PANTONE 2375	PANTONE 2727	PANTONE 2607	PANTONE 584	PANTONE 321	PANTONE 5825
PANTONE 157 — PANTONE 254	PANTONE 258 — PANTONE 2562	PANTONE 391 — PANTONE 2935	PANTONE 683 — PANTONE 326	PANTONE 126 — PANTONE 2955	PANTONE 683 — PANTONE 711

Unique 2

Communication Arts

INTERACTIVE
DESIGN
ANNUAL

4

call for
entries

You are invited to submit digital interactive projects to
Communication Arts magazine's fourth Interactive Design
Annual. Any interactive project created for digital distribution
on a floppy disk, CD-ROM, interactive kiosk, online service
or the World Wide Web is eligible.

Selected by a nationally representative panel of distin-
guished designers and art directors, the winning entries
will be reproduced on a CD-ROM bundled with copies
of the September/October 1998 issue of *Communication
Arts*. 70,000 copies will be distributed worldwide, assuring
important exposure for the creators of these
outstanding projects.

E-mail: shows@commarts.com
URL: www.commarts.com

THE CHERIO CATALOGUE

Swing

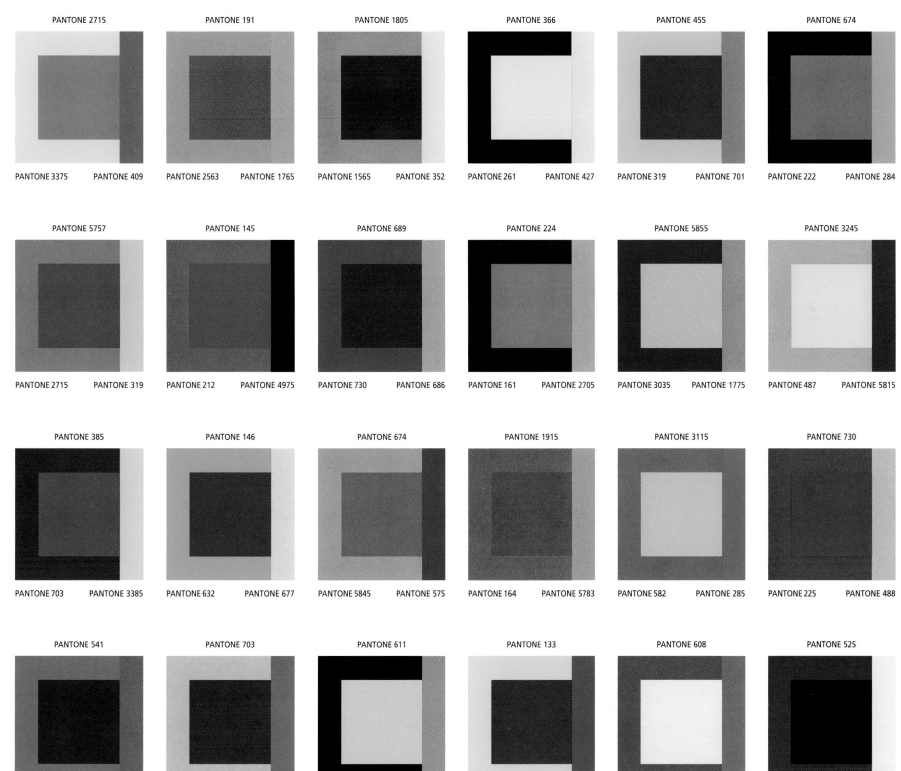

PANTONE 2715
PANTONE 3375 PANTONE 409

PANTONE 191
PANTONE 2563 PANTONE 1765

PANTONE 1805
PANTONE 1565 PANTONE 352

PANTONE 366
PANTONE 261 PANTONE 427

PANTONE 455
PANTONE 319 PANTONE 701

PANTONE 674
PANTONE 222 PANTONE 284

PANTONE 5757
PANTONE 2715 PANTONE 319

PANTONE 145
PANTONE 212 PANTONE 4975

PANTONE 689
PANTONE 730 PANTONE 686

PANTONE 224
PANTONE 161 PANTONE 2705

PANTONE 5855
PANTONE 3035 PANTONE 1775

PANTONE 3245
PANTONE 487 PANTONE 5815

PANTONE 385
PANTONE 703 PANTONE 3385

PANTONE 146
PANTONE 632 PANTONE 677

PANTONE 674
PANTONE 5845 PANTONE 575

PANTONE 1915
PANTONE 164 PANTONE 5783

PANTONE 3115
PANTONE 582 PANTONE 285

PANTONE 730
PANTONE 225 PANTONE 488

PANTONE 541
PANTONE 2573 PANTONE 479

PANTONE 703
PANTONE 516 PANTONE 144

PANTONE 611
PANTONE 2757 PANTONE 143

PANTONE 133
PANTONE 353 PANTONE 660

PANTONE 608
PANTONE 681 PANTONE 138

PANTONE 525
PANTONE 133 PANTONE 372

Unique 3

IT SAYS YOU'RE AN
INDIVIDUAL.
IT SAYS YOU'RE
PRESSIVE.

YOU'D ONLY ENTER
EN TO USE THE BATHROOM.

URNITURE GALLERY
Y BOULEVARD 254-1033

ABSOLUT CLEMENTE.

TBWA/CHIAT/DAY
© V+S Vin+ Sprit ab

patrickaldrick
patrickpatrick t

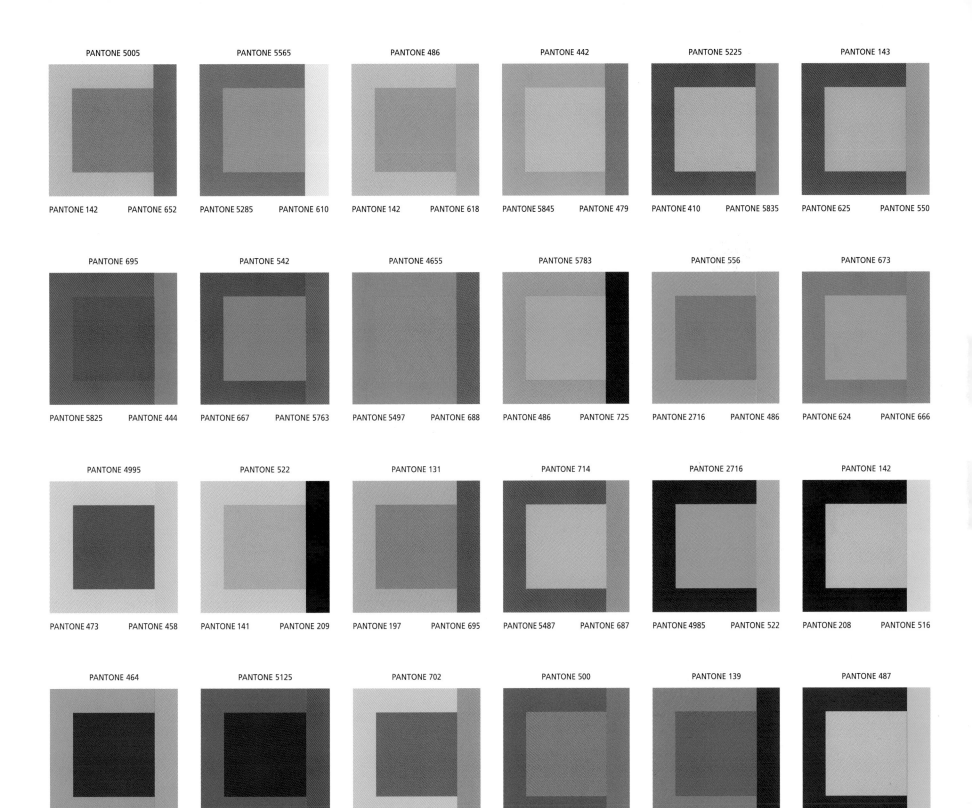

PANTONE 5005
PANTONE 142 PANTONE 652

PANTONE 5565
PANTONE 5285 PANTONE 610

PANTONE 486
PANTONE 142 PANTONE 618

PANTONE 442
PANTONE 5845 PANTONE 479

PANTONE 5225
PANTONE 410 PANTONE 5835

PANTONE 143
PANTONE 625 PANTONE 550

PANTONE 695
PANTONE 5825 PANTONE 444

PANTONE 542
PANTONE 667 PANTONE 5763

PANTONE 4655
PANTONE 5497 PANTONE 688

PANTONE 5783
PANTONE 486 PANTONE 725

PANTONE 556
PANTONE 2716 PANTONE 486

PANTONE 673
PANTONE 624 PANTONE 666

PANTONE 4995
PANTONE 473 PANTONE 458

PANTONE 522
PANTONE 141 PANTONE 209

PANTONE 131
PANTONE 197 PANTONE 695

PANTONE 714
PANTONE 5487 PANTONE 687

PANTONE 2716
PANTONE 4985 PANTONE 522

PANTONE 142
PANTONE 208 PANTONE 516

PANTONE 464
PANTONE 514 PANTONE 472

PANTONE 5125
PANTONE 723 PANTONE 581

PANTONE 702
PANTONE 458 PANTONE 457

PANTONE 500
PANTONE 730 PANTONE 5285

PANTONE 139
PANTONE 709 PANTONE 1805

PANTONE 487
PANTONE 724 PANTONE 346

Unique 4

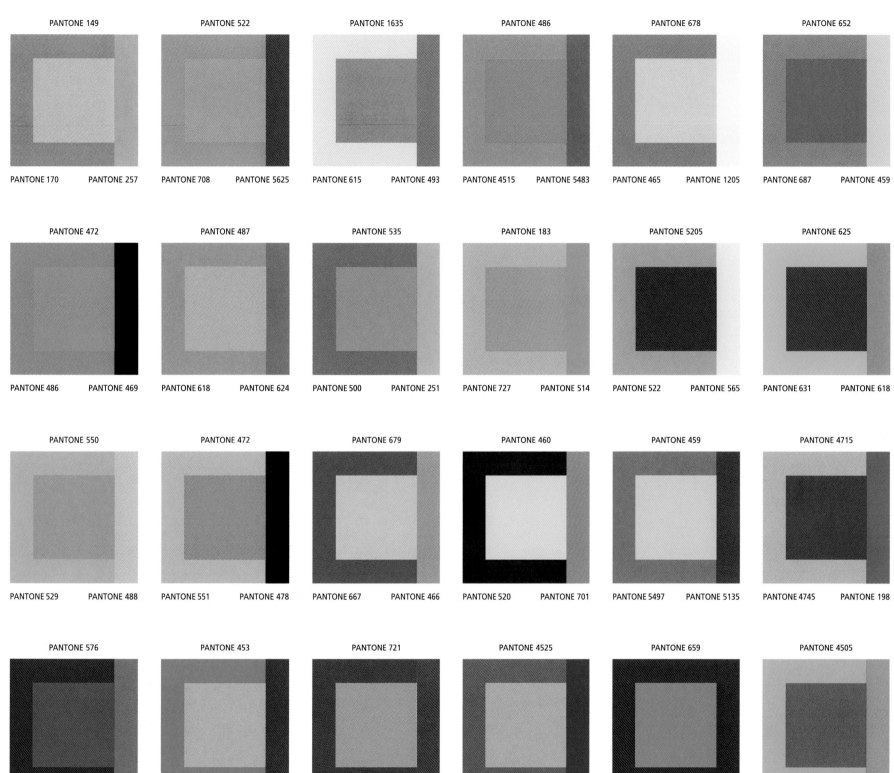

PANTONE 149
PANTONE 170 PANTONE 257

PANTONE 522
PANTONE 708 PANTONE 5625

PANTONE 1635
PANTONE 615 PANTONE 493

PANTONE 486
PANTONE 4515 PANTONE 5483

PANTONE 678
PANTONE 465 PANTONE 1205

PANTONE 652
PANTONE 687 PANTONE 459

PANTONE 472
PANTONE 486 PANTONE 469

PANTONE 487
PANTONE 618 PANTONE 624

PANTONE 535
PANTONE 500 PANTONE 251

PANTONE 183
PANTONE 727 PANTONE 514

PANTONE 5205
PANTONE 522 PANTONE 565

PANTONE 625
PANTONE 631 PANTONE 618

PANTONE 550
PANTONE 529 PANTONE 488

PANTONE 472
PANTONE 551 PANTONE 478

PANTONE 679
PANTONE 667 PANTONE 466

PANTONE 460
PANTONE 520 PANTONE 701

PANTONE 459
PANTONE 5497 PANTONE 5135

PANTONE 4715
PANTONE 4745 PANTONE 198

PANTONE 576
PANTONE 5545 PANTONE 5285

PANTONE 453
PANTONE 528 PANTONE 4495

PANTONE 721
PANTONE 5135 PANTONE 424

PANTONE 4525
PANTONE 416 PANTONE 675

PANTONE 659
PANTONE 371 PANTONE 5205

PANTONE 4505
PANTONE 2705 PANTONE 183

Naturals

*J*ust as the word natural implies, all that is authentic and serene: innate, effortless and without artifice. In terms of food, this is an "organic" palette — untreated, health-giving — ample servings of vegetal greens used in tandem with environmentally-correct neutral tones.

PRIMITIVE CHIC

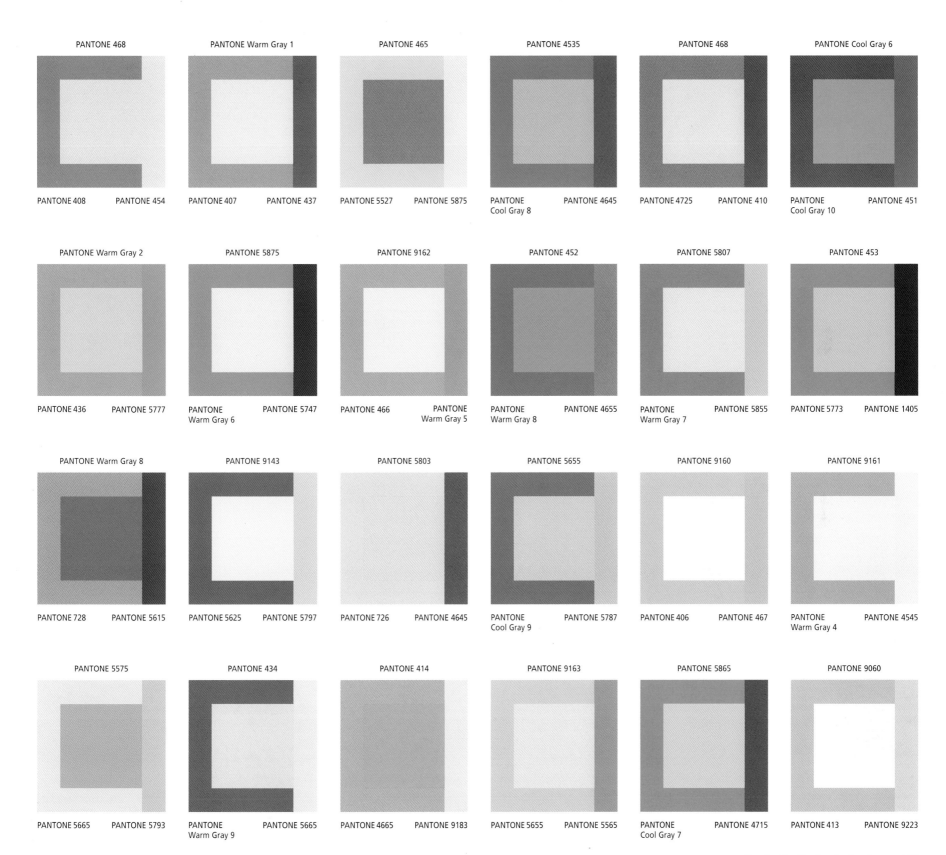

PANTONE 468
PANTONE 408 PANTONE 454

PANTONE Warm Gray 1
PANTONE 407 PANTONE 437

PANTONE 465
PANTONE 5527 PANTONE 5875

PANTONE 4535
PANTONE Cool Gray 8 PANTONE 4645

PANTONE 468
PANTONE 4725 PANTONE 410

PANTONE Cool Gray 6
PANTONE Cool Gray 10 PANTONE 451

PANTONE Warm Gray 2
PANTONE 436 PANTONE 5777

PANTONE 5875
PANTONE Warm Gray 6 PANTONE 5747

PANTONE 9162
PANTONE 466 PANTONE Warm Gray 5

PANTONE 452
PANTONE Warm Gray 8 PANTONE 4655

PANTONE 5807
PANTONE Warm Gray 7 PANTONE 5855

PANTONE 453
PANTONE 5773 PANTONE 1405

PANTONE Warm Gray 8
PANTONE 728 PANTONE 5615

PANTONE 9143
PANTONE 5625 PANTONE 5797

PANTONE 5803
PANTONE 726 PANTONE 4645

PANTONE 5655
PANTONE Cool Gray 9 PANTONE 5787

PANTONE 9160
PANTONE 406 PANTONE 467

PANTONE 9161
PANTONE Warm Gray 4 PANTONE 4545

PANTONE 5575
PANTONE 5665 PANTONE 5793

PANTONE 434
PANTONE Warm Gray 9 PANTONE 5665

PANTONE 414
PANTONE 4665 PANTONE 9183

PANTONE 9163
PANTONE 5655 PANTONE 5565

PANTONE 5865
PANTONE Cool Gray 7 PANTONE 4715

PANTONE 9060
PANTONE 413 PANTONE 9223

Color Symbolism & Trends

Color has always been used symbolically, whether painted directly on the body or worn in garments to announce the wearers' social status, their tribe or country or other significant group. Humans have always used color in their surroundings for decorative purposes or to chronicle their every day lives and other important events. Throughout history, color has consistently been a critical factor in determining the choice of bartered or bought goods. In most cultures, color choice is not haphazard as each hue has a very meaningful and/or magical effect.

Historically, royalty, those in exalted positions and the privileged classes set the taste level. Almost everyone (those who could afford it) dressed and decorated in much the same way.

During the Victorian Age, the upper class hungered for opulent colors and fabrications while those of more humble means fantasized and imitated as best they could.

The Puritan ethic still existed as Gustav Stickley, the father of the bungalow and of mission furniture warned the American public: "When luxury enters in and a thousand artificial requirements are regarded as real needs, this nation is on the brink of degeneration." (Gustav was not a fun kind of guy!) Consumer products demonstrated practical neutral colors, especially as advertising was seen largely in sepia tones.

While the masses lived in less colorful surroundings, the wealthy continued to furnish their grand estates with rococo embellishments and sumptuous color — at least until the crash of 1929.

At this point in time, it became very clear that color, or the lack of it, can reflect the emotional make-up of an entire decade. For example, women of the 1930s looked to the movies for their inspiration. To help lift their spirits after the bleakness of the great depression, they imitated screen goddesses like Jean Harlow and wore white, off-white and lightened pastels. The newly-spawned "interior decorators" started the trend to utilizing those same tints in the home. Consumer products and advertising reflected these same light touches.

Battleship gray, navy and military khaki ruled during World War II. But once the war ended, so did the somber tones that reflected those serious years of deprivation and color made a comeback. Having replaced men in wartime industries, Rosie the Riveter of the 40s returned to being Susie Homemaker in the 50s. Reflecting the "pink-is-for-girls-mom-in-the-kitchen-father-knows-best mentality, she was admonished to "think pink" — to wear pink lipstick, drive a pink car or buy pink household appliances — all of which was reinforced by an all pink fashion sequence in the classic Audrey Hepburn Technicolor film, *Funny Face*. The quintessential icon of femininity, Barbie, was born and much of the time, she wore pink.

Encouraged by the social and sexual revolution of the 60s, clashing flower-power brights became the rage. In this often chemically altered drug culture, colors were rendered more brilliant. The BEATLES sang about yellow submarines and Peter Max celebrated psychedelic color. Buying a color TV was the goal of every household.

By the time the 70s arrived, everyone was satiated with color. The pendulum swung once again, this time to down-to-earthtones — harvest gold, rust and, as thought of in more recent years, the dreaded A word — avocado. By the end of the decade, vibrant color emerged once again with the advent of the disco craze, flashing strobe lights and glittery brights.

The 80s saw a more rapid time of color change, spawned by the beginnings of the "information age" with computers and satellites offering quicker methods of exchanging information. The beginning of the decade saw the "mauving" of America — the softened mid-tones that were a precursor to the Santa Fe colors that followed as people all over the world started to discover America's southwest and the desert sunset hues. And as population started to move in greater

Color Factoid

Although they may weigh exactly the same, all pastel shades are seen as lighter in weight than dark shades.

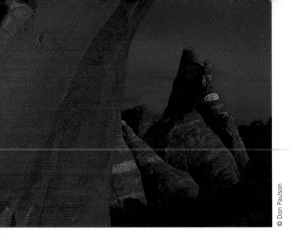

© Don Paulson

numbers into the sunbelt states, interest in those colors became even greater. In addition, the revival of Miami Deco architecture brought attention to brightened pastels and TV's *Miami Vice* proved that real men could wear lavender!

But the mid-80s saw yet another color phenomena — the pervasiveness of empowering black with all of the trappings of elegance, sophistication and high-tech applications. This was the age of conspicuous consumption — limos and tuxes, Chanel and tough chic. Shiny black furnishings and appliances were "in" and for the first time ever, food was packaged in black and people paid more for the privilege of purchasing those "designer" foods! Vibrant colors were often juxtaposed against black as consumers

celebrated consumption with their over-extended credit cards.

The 90s arrived with a resounding thump. The economy took a big slump and it was time for a reality check. A skittish economy brought the need to pare down, to simplify and go with the "safe" neutrals. "Cocooning" was the operative word with people retreating (or being downsized) into the safety of their homes. The bland were leading the bland. In addition, the "grunge" music scene fed into murky shades. A new ecologically aware consumer consciousness arose and everyone was concerned about saving the rain forests. Recycled paper in tones of beige replaced pristine bleached whites.

In this newly awakened environmentally-correct atmosphere, it was time for the color family that has always symbolized nature to re-emerge — the greens. Companies were thinking "green" and so were the designers and colorists that were choosing colors for the products. In addition to the earthy greens there were other earth-bound warm reds, golden yellows, terra cotta and rich brown (reinforced by the craze for coffee).

By the mid 90s, the economy was brighter and so were the colors. Many more consumers were into computers; consumers and designers alike were fascinated with the electronically produced colors emanating from their computer screens. And with this increased computer involvement came the ability to see and study colors from all over the globe that only print media, films and television shows had previously provided. This colorful multi-ethnic mix of colors from all over the world inspired exotic color palettes for all manner of consumer goods.

As the end of the decade and the new century came into view, consumers were simultaneously excited by the future yet yearning to hold on to the security of the past. "Retro" looks and colors evolved, each reflective of many of the eras previously described. From yo-yos to the revival of the classic VW Beetle, very little in the way of clothing, home furnishings, or other consumer products escaped the nostalgia trip. Yellow kitchens, red lipsticks, blue plate specials, white sheets and yes, the return of the once-dreaded olive tones, now revisited as the precise shade of green in newly chic martinis.

In the 21st century, consumers continue to want more color options. They are better educated about color, appreciate guidance and intelligent advice but will not be dictated to regarding their choices. They have come to recognize that the colors that best reflect their lifestyles help them to achieve their own comfort level. They look to coordinated palettes of colors for guidance in creating color combinations for use in their homes, businesses and clothing. No matter what the product, the consumer must respond on some emotional level to the colors of the product, the advertise-ment, the Web site, the commercials, the packaging, or the point of purchase appeal.

In this fast-forward, instant gratification, e-mail connected world trends can be communicated and/or change course with the click of a mouse or a remote control. It behooves the savvy designer or anyone else involved with the production, advertising or market-ing of consumer goods to stay on top of the trends not only in his or her own industry but in the world at large. Color is only one part (and a very large part) of the big picture.

Where do the color trends come from? Is there a small group of color dictators wield-ing their absolute powers over an unsuspecting public? What brings a color into public awareness and predisposes the public to want those colors? It is not a malevolent color cabal that manipu-lates the public taste; it is much less a conspiracy than a melding of ideas and color concepts. Color stylists, designers, consultants

and forecasters are the visionaries: they are fine-tuned to the foibles, fads and future events that create the color trends.

They are well aware that the human eye is not only attracted by novelty, but is exceedingly fickle. A reinvigorated color, or colors used in novel combinations and finishes can satisfy the need for newness.

Even the most dedicated traditionalist can be tempted by the introduction of a "new" color in packaging, for example, that may not be new at all, but is simply a new "take" on the way a color is used. Skewing a true red to a trendier reddish plum and using it with a peacock blue-green rather than a predictable deep green can make the roving consumer eye, no matter how conservative, take notice.

There are, of course, the trend-makers and the trend-followers. There are clients more willing to push beyond the norm and those who would rather

wait and not take the plunge into more colorful waters. There are thousands of stories about companies that would simply not take the risk and did the same-old, more than slightly worn-out color stories in their product offerings or logo designs, only to be out-distanced by the competition that would be more innovative with color and, as a result, ultimately gain more market share.

This does not mean abandoning successful and established brand image colors that have helped to establish a corporate identity and "persona," especially in corporate logos and identification. The psychological impact of the colors should always be factored into the design regardless of the trends to "new" colors. This book and the color combinations illustrated here are an essential guide to creating a variety of themes so essential to communicating appropriate messages.

Color Forecasting

At one point in time, it was very simple to track the descending order of color trends and the amount of time it took to trickle down from one industry to another. But more recently, because of the rapid-fire availability of information and the newer technologies available to produce color in various applications, the lines between industries have become increasingly blurred.

The turn-around time from drawing board to selling floor is more problematic in some areas because of actual production time, but many manufacturers, based on their willingness to adapt more quickly and take advantage of new color directions, are making a concerted effort to integrate the trends rapidly. Yet others opt to move more deliberately, to evolve rather than constantly revolve. In the final analysis, each color change, addition or deletion has to be done very thoughtfully depending on the nature of the product or image. There are no "magic bullets."

Color forecasting involves an intrepid perusal of all the issues and happenings that might influence color directions in the future. The

Internet, various periodicals, television shows that report on trends, trade shows and color forecasting organizations are excellent sources of trend information. As the information is so readily available, products destined for color changes are limited only by the time constraints demanded by research, development and manufacturing. The many areas to watch for signs of impending colors include:

The World of Fashion

The colors that march down the fashion runways inevitably will find their way into consumer products and will influence every area of design. It is the first place to look for "cutting edge" color. The question inevitably arises, where does fashion look for direction? Fashion designers will often look to the areas noted on the

following pages for their directions, or they may simply follow a flight of fancy, inspired by some exotic travel experience. Or they might have seen a new fabric at a textile show or mill that spawns a whole new color direction. There are

some that believe that the textile designers/manufacturers are the real visionaries, especially as they work with gifted designers in developing new colorways.

At one time, it was believed all of the strongest influences came from haute couture and then trickled down to the lowest price levels. But that started to change during the 60s as young people started to "invent" their own innovative looks and color combinations. Color and style can start with street fashion and work its way up onto the drawing boards of high fashion. For example: when young people started to shop in secondhand stores for vintage or retro fashions, designers took note and introduced those looks and colors into their collections.

The Entertainment World

The world of music, as well as the location and theme of films and popular television shows, especially those in the production phase, can be very influential. The media, especially those dedicated to entertainment, will often show photos of the scenes and stars, or write about future shows that will provide hints about upcoming

colors. This same information may appear simultaneously on the Web. It's important to look at the colors that the rising stars or most visible performers are wearing, especially when they are performing, as they are apt to be the most "fashion-forward." The hottest sports activities or team colors can also inspire color trends.

Museum Collections

There is often much pre-publicity about upcoming museum exhibits, especially those that travel around the world. When a particular artist is featured, such as Gaughin for instance, the brighter tropical colors will provide inspiration in many areas of design. When the King Tut exhibit worked its way around the world and huge throngs of people attended the showings, metallic gold finishes became the rage in fashion, interiors and in print.

Economic Issues

This may be hard to imagine, as economic considerations seem so far removed from color or design, yet it can be one of the most influential areas as far as color is concerned. The state of the economy definitely has a psychological impact on the very practical aspects of spending money on various products. When the economy is down, people are more apt to be less colorful, opting instead for neutral colors. When people are more optimistic, they're inclined to take riskier choices with more vibrant color. This is one of the trickiest areas to prognosticate and often the colors are based on wishful thinking rather than reality.

Sociological Issues

It's a given that war or involvement in peace-keeping efforts will bring a flurry of colors associated with those events, such as military greens and tans. The colors of the flag are also popularized during a patriotic upsurge or during a time of celebration and/or competition such as a centennial celebration, the Americas' Cup, the Olympics, or a big political event such as a presidential election. A social issue of major concern may also bring awareness to a particular color family. The 60s brought the first real look at environmental issues with the publication of

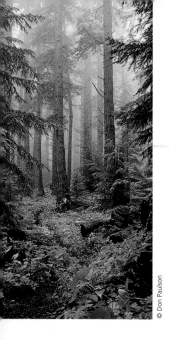
© Don Paulson

Rachel Carson's awakening call in her book, *Silent Spring*. This was a precursor to the earth tones, especially avocado green, becoming popular later in the decade. In the 90s, earth tones were revisited as a result of the enormous interest and concern in ecology and the preservation of the environment.

Cyclical Patterns

All trends travel in "waves" or cycles, exhibiting a natural progression of high and low popularity. For example, the early 80s with the strong trend to mauve, gray and teal in interiors and consumer products was a relief after the pervasive earthtones that preceded them. As is often the case, the complementary colors on the color wheel are often (but not always) visited to offer a sense of newness. This was especially important, as there was such overkill in the use of avocado and earthtones that many consumers were simply sick of them. They couldn't face yet another shag carpet in harvest gold! So the carpets and practically every other consumer product were transformed into mauve. When mauve became pervasive, it too got very tired in time.

The best way to overcome this exhaustion with a color is to use it in new and inventive color combinations. A single color itself is less apt to get old, if it is revitalized in new combinations. If mauve provides the appropriate psychological impact for a specific package, it should not be totally avoided because it is not a current trend, but should be utilized in a fresh new color combination, avoiding the cliched combinations of the past.

Lifestyles

There are insights that can be gleaned from various periodicals or reports about popular pursuits or lifestyle choices. What are the favorite forms of recreation and what do people usually wear when they are involved in these activities? Will the emphasis be on high-energy, adrenaline pumping sports that cry out for bright colors, or will they be more relaxed and in tune with the natural surroundings that call for natural, non-synthetic looking colors? Will more people continue to work at home and wear comfy gray sweats or other easy casual wear like khakis and jeans? This may seem more like a fashion issue, but these choices will at some point influence the colors of other consumer products.

Color Factoid
Those people living closer to the equator are more drawn to warm and/or bright colors.

Multi-Cultural Mixes

The U.S. has always been a vast mixture of different ethnicitys, each with its own tastes, value systems, customs and culture. There are high concentrations of various ethnic groups in specific areas of the country where cultural connotations of color are tied to traditional roots. For example, the southwest region of the U.S. with the large Latino population has literally enriched the marketplace with salsa and chili pepper reds. It has been reported that salsa is now outselling catsup! This is a perfect example of how shifting populations internationally and waves of immigration eventually bring new color influences to the population at large.

Increased global travel, instant communication via satellite and the Web enables people all over the world to experiment with the colors and combinations of diverse ethnic groups. The challenge is to observe where these shifts and new infusions are coming from. It is important to note that color limitations in various geographic areas are rapidly diminishing as a result of mass distribution, mail order, shopping on the Web and the proliferation of mass-market chains.

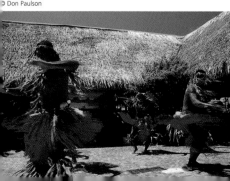
© Don Paulson

Technology

Technology brings ever-changing advances in design and color. It's important to stay on top of the newer methods of creating color and how that might influence color palettes. For example, multi-colored metallics that vary with the light source, new forms of gloss and reflective finishes, pearlescent and iridescent specialty effect pigments available in industrial applications for plastics, coatings, cosmetics and printing inks offer a whole new world of color possibilities. The use of Hexachrome® is certainly an example of how far the printing process has come in producing true color.

Buzzwords

Keep your ears tuned to the newest buzzwords. For example, what does "authentic" say to you? Does it say real, without artifice, natural, genuine? Could it also mean a traditional and/or classic mood? Are spiritualism and a fascination for the supernatural a continuing interest that captures the public attention? If this is so, match the descriptive buzzword to one of the closest moods depicted in this book and that will give you a sense of where the color direction is going as well as the recommended combinations to get you there.

Credits

Absolut advertisement
TBWA/CHIAT/DAY
© V&S VIN & SPRIT AB

Bluefly.com advertisement
Bluefly.com
Illustrator: John Pirman, Art Director:
Bluefly.com

Page 42
Ponds advertisement
Conopco, Inc. dba Chesebrough-Pond's
USA Co. and/or Unilver Home & Personal
Care USA

Page 43
Humalog packaging
The DeLor Group

Page 44
Monadnock Paper – Green Giant Fork
Pollard & Van de Water

"Garden Design" magazine
Courtesy of "Garden Design Magazine"/
Meigher Communications
Designers: Michael Grossmann, Toby Fox
Photographer: André Baranowski

Landmark Tommi Boutique packaging
Tommy Li Design Workshop

Weddingbells Inc. sales brochure
© WEDDINGBELLS, Inc.

Page 45
Kiva Day Spa packaging
Chute Gerdeman, Inc.
Photographer: Douglas Reid Fogelson

VW Bug advertisement
Volkswagon of America
Arnold Communications

Monica Stevens photograph
© Monica Stevenson Photography

Page 46
Absolut advertisement
TBWA/CHIAT/DAY
© V&S VIN & SPRIT AB

Page 47
Bejing Hair Culture corporate identity
Tommy Li Design Workshop

Page 48
Zanders promotional brochure
NDW Communications
Creative Director: Ted Bell, Art Director:
Bill Healey, Designer: Bill Healey, Copywriter:
Margaret Frasier, Photographer(s):
Dan Naylor, Rodney Oman/various

Robert Allen advertisement
The Robert Allen Group
Designer: Robert Allen

Kohler advertisement
Kohler, Co., Kohler, Wisconsin

Page 49
Wines From Spain advertisement
Wines From Spain

Purple Yarn
Photographer: Herb Eiseman

Smoothieville advertisement
West & Vaughan
Chief Creative Officer: Bill West,
Creative Director: Robert Shaw West,
Art Director/Designer: Rob Baird, Copywriter:
Eran Thomson, Photographer: Vic Cotto,
Retouching/Production: Harperprints

Storm advertisement
"Storm" is a trademark of Sun 99 Ltd.

Page 50
Faraway Products promotional items
Kuester Partners
Designers: Kevin Kuester, Bob Goebel,
Elvis Swift

Page 51
Karastan sample folder
Sage
Art Director: Vicki Strull, Designers:
Vicki Strull, Catherine Wells, Jason Snape,
Illustrator: Laura Ljungkvist, Copywriter:
Nicole A. Lillis

Page 52
Tufenkian Tibetan Carpets brochure
James Tufenkian

Hotel Astor identity package
Turkel Schwartz & Partners
Creative Directors: Bruce Turkel, Kirk Kaplan,
Art Director/Designer: Rebecca Carlson

Jackson Hole Ski Resort advertisement
Jackson Hole Ski Resort
Designer: F.J.C. and N

Page 53
Robert Allen advertisement
The Robert Allen Group
Designer: Robert Allen

Waste Awareness Network advertisements
West & Vaughan
Chief Creative Officer: Bill West, Creative
Director: Robert Shaw West, Art Director:
Shawn Brown, Copywriter: Anne-Marie
Norris, Photographer: Photonica, stock

Shaklee packaging
Primo Angeli, Inc.

Paprika Communications promotion
Paprika Communications
Art Director: Louis Gagnon, Designer: Francis
Turgeon, Printing: Litho Acmé

Page 54
Pinehurst Candles direct mailer
West & Vaughan
Chief Creative Officer: Bill West, Creative
Director: Robert Shaw West, Art Director:
Shawn Brown, Copywriter: Eran Thomson,
Photographer: Vic Cotto, Retoucher: Todd
Bengler

Page 55
Baby Bee packaging
Burt's Bees, Inc. – Art Department

Page 56
Club Monaco packaging
Dinnick & Howells
Art Directors: Jonathan Howells,
Sarah Dinnick, Designers: Sarah Dinnick,
Samantha Dion

Finch Paper brochure
Finch Paper
Creative Director: Rob Deluke, Art Director:
Rob Deluke, Photographer: Mark McCarty

Page 57
White Sale advertisement
The Company Store
Photographer: Frank Fortis

Ace Bakery packaging
Dinnick & Howells
Art Directors: Jonathan Howells,
Sarah Dinnick, Designer: Sarah
Dinnick,Samantha Dion

VW Bug advertisement
Volkswagon of America
Arnold Communications

Page 58
Guinness Draught Packaging
Primo Angeli, Inc.

Page 59
Chanel advertisement
Chanel, Inc.
Photographer: Nick Welsh
"© 1999 Chanel, Inc."

Page 60
Monadnock Paper – Tights and Shoes
Pollard & Van de Water

The Hogue Cellars packaging
The Leonhardt Group
Lead Designer: Ray Ueno, Designer: Steve
Watson

Holocaust Lecture poster
University of Texas at Dallas
Art Directors: Mark Steele, Marian Moore,
Illustrator: Mark Steele

Exposure Fashion Boutique
corporate identity
Tommy Li Design Workshop

Page 61
Finch Paper brochure
Finch Paper
Creative Director: Rob Deluke, Art Director:
Rob Deluke, Photographer: Mark McCarty

Robert Allen advertisement
The Robert Allen Group
Designer: Robert Allen

Seven Designers Poster
Tommy Li Design Workshop

Page 66
Pier 1 Imports catalog
Pier 1 Imports Advertising Department

Burt's Bees packaging
Burt's Bees, Inc. – Art Department

The Bahamas Tourism Institute logo
Irma S. Mann Strategic Marketing, Inc.
Designer: Irma Mann

Neiman Marcus advertisement
Shu Akashi Photo
Photographer: Shu Akashi

Comforter, catalog item
The Company Store
Photographer: Frank Fortis

Page 68
Mohawk Paper booklet
Hornall Anderson Design Works, Inc.
Art Directors: Jack Anderson, Lisa Cerveny,
Designers: Jack Anderson, Lisa Cerveny, Mary
Hermes, Jana Nishi, Jana Wilson Esser,
Virginia Le, Photographer: Tom Collicott,
Copywriter: Suky Hutton

Tufenkian Tibetan Carpets brochures
James Tufenkian

"North, South, East, West-American Indians
and the Natural World" book cover
Carol Haralson Design
Designer: Carol Haralson, Publishers:
Carnegie Museum of Natural History and
Roberts Rinehart

Coffee Paper shopping bags
The Greteman Group
Art Director: Sonia Greteman,
Designer/Illustrator: James Strange

Page 70
Seasons, Inc. catalog
Seasons, Inc.
Photographer: Nancy Nolan

CBI Laboratories packaging
Desgrippes Gobé
Design Director: Susan Berson, Photographer:
Paul Tillinghast

Women's Health brochure
The North Shore Medical Center
Designer: Dariotis Design/Steve Dariotis

Christian Dior advertisement
Christian Dior, Paris

Page 72
Blue Acorn Studios, Inc. t-shirts
Blue Acorn Studios, Inc.
Designers: Kara Thurmond, Jennifer Lang

Pfaltzgraff advertisement
The Pfaltzgraff Co.

L'eau d'Issey packaging
Karim Rashid, Inc.
Designer: Karim Rashid

Champion Paper advertisement
Champion International Corporation
Designer: Lucille Tenazas

Page 74
Walker Creative, Inc. gifts
Walker Creative, Inc.
Designer: Joan Frieburg, Art Director:
Steven Walker

Dirty Girl Soap packaging
Haley Johnson Design
Designer/Illustrator: Haley Johnson

The Interchurch Center in NYC logo
Ching Foster Design
Designers: Donna Lee Ching, D. Jonathan,
B. Foster

Insider's Guide to Dallas booklet
Studiographix
Designers: Bob Mynster, Jan Pults/The Dallas
Society of Visual Communications

Waterworks advertisement
Studio XL
Art Director: Rick Biedel, Photographer:
Stephen Lewis

Page 76
Pier 1 Imports catalog
Pier 1 Imports Advertising Department

The Interfaith Airport Chapel
advertisements
BaylessCronin
Creative Director/Art Director: Chris Schlegel,
Copywriter: Jay Wallace, John Spear

Elbow Beach advertisement
Turkel Schwartz & Partners
Creative Directors: Bruce Turkel, Kirk Kaplan,
Art Director/Designer: Rebecca Carlson,
Copywriter: Kimberly Maddig

"Tina Modotti-A Life" book cover
St. Martin's Press
Creative Director: Steve Snider

Page 78
Cinderella
DISNEY Publishing Worldwide
DISNEY Children's Book Group, LLC
© Disney Enterprises, Inc.

Dining room
Yankee Clipper Inn, Rockport, MA
Photographer: Gabor Demjen

"An Ocean Apart" book cover
St. Martin's Press
Creative Director: Steve Snider

Grasmere Floral advertisement
Studio 3 Photography
Photographer: M. Benedicte Verley

Page 80
Ma Belle Jewelry Boutique packaging
Tommy Li Design Workshop

Nescafé-Frothe packaging
Primo Angeli, Inc.

Ironware International products
Ironware International
Art Directors: Karin Eaton, B. Middleworth,
Designer: B.Middleworth, Photographer:
Mark Tucker, Stylist: Karin Eaton,
Backgrounds: Carrie McGee

Pantone advertisement –"Joy of Color"
Courtesy of Pantone, Inc.

Page 82
Calendar for Häfele
Elberson Senger Shuler
Art Director: John Roberts, Production: Elaine
Franklin, Printer: CADMUS Promotional
Printing

Redesign of *Life* magazine
School Of Visual Arts
Instructor: Paula Scher, Designer: Donna
Reiss, Photographers: Rwanda Cover-Roger
Lemoyre, Gamma-Liaison

Juvenile Diabetes Foundation
International poster
The Partnership, Inc.
Creative Director: David Arnold, Designer/
Illustrator: Anne-Davnes Dusenberry

Kinko's advertisement
Kinko's, Inc.
"© 1999, Kinko's, Inc. All rights reserved."

Page 84
Zima packaging
Primo Angeli, Inc.

Neiman Marcus advertisement
Shu Akashi Photo
Photographer: Shu Akashi

Rugs, catalog item
The Company Store
Photographer: Frank Fortis

Fendi advertisement
Fendi/Taramax U.S.A.
Photographer: Riccardo Abbondanza,
Creative Director: Len Schaktman

Christian Dior advertisement
Christian Dior

Page 86
The Hogue Cellars packaging
The Leonhardt Group
Lead Designer: Ray Ueno, Designer:
Steve Watson

Coffee-Black Invitation
Coffee-Black Advertising
Creative Directors: Troy Scillian, Jim Sykora,
Art Director: Aaron L. Opsal, Copywriter:
Chris Shafer, Photographer: Rusty Hill

El Paso Chile Co. packaging
RBMM
Art Director/Designer/Illustrator: Horacio
Cobos

Pyramid Ales advertisement
Cole & Weber

Sutter Home Wine packaging
Michael Osborne Design, Inc.

Page 88
Shiseido Skin Care packaging
Shiseido Co. Ltd.

Baby
Photographer: Peter Luers

"Saul" book cover
St. Martin's Press
Creative Director: Steve Snider

Sheets, catalog items
The Company Store
Photographer: Frank Fortis

Page 90
Line & Tone advertisement
Line & Tone
Creative Director: Notovitz Design, Designer:
Notovitz Design, Copywriter: Notovitz
Design, Photographer: Pascal Daumas, Printer
and Prepress: Line & Tone

Lehigh Press brochure
The Lehigh Press, Inc.

Royal Velvet advertisement
Pillowtex Corporation
Art Director: Steve Davis, Photographer:
Greg Slater, Copywriter: Naomi Maloney

"I.D. Magazine"
Reprinted courtesy of "I.D. Magazine", New
York.

Life Guard Station photographs
Paresky.com
© Laura Paresky

Jamie's Kids logo
Rory Myers Design
Art Director/Designer: Rory Myers

Page 92
Design Edge advertisement
Design Edge
Designer: Jane Brooks, Photographer:
Bill Albrecht

Mustang GT advertisement
Courtesy of Ford Motor Company

Indy Jazz Fest logo
Caldwell Van Riper/MARC
Creative Director: Bryan Wadlock,
Art Director/Illustrator: Justin Gintner

Wools of New Zealand brochure
Wools of New Zealand, Ltd.

TYR Sport brochure
Michael Dula Design
Art Director: Michael Dula, Photographer:
Lori Adamski-Peek

Page 94
Fireplace products, catalog items
Sundance Catalog Company
Michael McRae Photography, Artisan
Colour Inc.

Ferris & Roberts packaging
Primo Angeli, Inc

Martha's Vineyard Candlemakers
advertisement
Martha's Vineyard Candlemakers
Designer: John Hallett Design

Henry Weinhard's Rootbeer packaging
Primo Angeli, Inc.

Page 96
"Masquerade" book cover
St. Martin's Press
Creative Director: Steve Snider

Elisabeth Anderson Poster
Jon Flaming Design
Designer/Illustrator: John Flaming Design

Judah L. Magnes Museum poster
St. Hieronymus Press, Inc.
Designer/Illustrator: David Lance Goines

Page 98
Squires & Company invitation
Squires & Company
Designer: Christie Grotheim, Illustrators:
Christie Grotheim, Paul Black, Brandon
Murphy, Veronica Vaughn

Fruit Roll-ups packaging
Primo Angeli, Inc.

Bloomin' Flower Cards
Bloomin' Flower Cards, Inc.

Cherio Song Title Catalog
Kevin Akers Design
Designer/illustrator: Kevin Akers

Whitehall Lane Winery label
Tower Design Studio
Art Director: Kathleen Anne McMullen,
Designers: Erin M. Keebler, Kathleen Anne
McMullen

Page 100
Tilex packaging
Primo Angeli, Inc.

Family Circle t-shirt
Leibowitz Communications
Art Director: Paul Leibowitz, Designer: Rick
Bargmann, Photographer: Dan Wilby

Flax Art & Design catalog cover
Flax Art & Design
Designer: Rebecca Lyon

Pillows, catalog items
The Company Store
Photographer: Antoine Bootz

Page 102
L'eau d'Issey packaging
Karim Rashid, Inc.
Designer: Karim Rashid

Sappi brochure
Siegel & Gale
Creative Director: Cheryl Heller,
Design Director/Designer: Veronica Om,
Photographers: Aeronout Overbecke,
François Robert, Cheryl Heller

Monadnock Paper – Bombay Gin Bottle
Pollard & Van de Water

Monadnock Paper – Bubbly Glass
Pollard & Van de Water

Crystal Geyser label
Primo Angeli, Inc.

Page 104
Nadia Comaneci, Gymnast
Stewart, Tabori & Chang, Inc
Photographer: Howard Schatz
© 1999 Stewart, Tabori & Chang
© Schatz/Ornstein, 1998

"Two Kitchens in Provence" Illustration
"Thurber Works" Illustration
Schumaker
Designer/Illustrator: Ward Schumaker

Sundance Catalog
Sundance Catalog Company
Michael McRae Photography, Artisan
Colour Inc.

Palais Royal advertisement
Palais Royal

Neiman Marcus advertisement
Shu Akashi Photo
Photographer: Shu Akashi

Page 106
Almond Roca Packaging
Primo Angeli, Inc.

Hard Candy Cosmetics packaging
Blue Creative Group
Art Director: Michael Gorey, Designer:
Thomas Fong

Dessert
Location: Yankee Clipper Inn, Rockport, MA
Photographer: Gabor Demjen

Biscotti packaging
Primo Angeli, Inc.

Mrs. Beasley's catalog
Mrs. Beasley's

Page 108
Juice 2 packaging
Primo Angeli, Inc.

Old El Paso advertisement
The Marlin Company
Art Director: John Rutkowski, Designer:
Steve Krone, Copywriter: Mike Rocco,
Photographer: Tom Davis

McIlhenny Company's advertisement
McIlhenny Company
"The TOBASCO® marks, bottle and label
designs are registered trademarks and service
marks exclusively of McIlhenny Company,
Avery Island, LA 70513."

Page 110
Board Game Graphics
Greteman Group
Art Director: Sonia Gretemen, Designer/
Illustrator: James Strange, Copywriters:
Deanna Harms and Todd Gimlin

Cherio Song Title Catalog
Kevin Akers Design
Designer/Illustrator: Kevin Akers

"The Language of Threads" book cover
St. Martin's Press
Creative Director: Steve Snider

INVESCO advertisement
The Richards Group
Art Director: Kristie Guilmette, Copywriter:
Cally Shea, Illustrator: Craig Frasier

Page 112
San Francisco Design Solutions brochure
Cahan & Associates
Art Director: Bill Cahan, Designer/Illustrator:
Kevin Roberson, Copywriter: Stefani Marlis

Cherio Song Title Catalog
Kevin Akers Design
Designer/Illustrator: Kevin Akers

VIA by Hammermill shopping bag
Williams and House

Móz Designs, Inc. catalog
Móz Designs, Inc.

"Communication Arts" advertisement
Communication Arts
Designer: Mark Eastman

Page 114
"Hong Kong Print Awards" poster
Tommy Li Design Workshop

Vivian Lai's CD Packaging
Tommy Li Design Workshop

Fuel Razorfish stationery
Fuel Razorfish
Designer: Jens Gehlhaar

Absolut advertisement
TBWA/CHIAT/DAY
© V&S VIN & SPRIT AB

Diamond Furniture Gallery advertisement
Fahlgren Advertising/Tampa
Art Director: John Stapleton, Creative Director:
Scott Sheinberg, Copywriter: James Rosene

Page 116
Andersen Consulting advertisement
Andersen Consulting
"©1999 Andersen Consulting, all rights reserved"

Hong Kong Golf Club Competition poster
Tommy Li Design Workshop

STDM corporate identity
Tommy Li Design Workshop

Byerly's Bag brochures
Design Center
Designers: Corey Docken (Organic Foods),
Sherwin Schwartzrock (Bread)

Page 118
Amangani Resort sales kit
Riddell Advertising & Design
Designer: Jeffrey Williamson, Copywriter:
Greg Wheeler, Illustrator: Dwayne Coleman,
Photographer: Lesley Allen, Account Planner:
Terri Kummer

Tufenkian Tibetan Carpets brochures
James Tufenkian

Hyatt Resort packaging
Primo Angeli, Inc.

Park B. Smith, Ltd. advertisement
Park B. Smith, Ltd.
Designer: Miriam Alvarez, Photographer:
Hadhazy Studio, Inc., "Exclusive property of
Park B. Smith, Ltd. © PBS, Inc."

Franchi Famiglia packaging
Palazzolo Design Studio
Creative Director: Gregg Palazzolo,
Art Director: Troy Cough, Photographer: Julie
Line, Printer: Station Printshop, Litho Labels

Page 120
Colorful Lady
Photographer: Herb Eiseman

Page 122
Sage identity and t-shirt
Sage
Art Director: Vicki Strull, Designers:
Vicki Strull, Catherine Wells, Jason Snape,
Illustrator: Laura Ljungkvist, Copywriter:
Nicole A. Lillis

Zima packaging
Primo Angeli, Inc.

Page 123
Fontmart.com logo
Born to Design, Designer/Illustrator: Todd
Adkins, Typography/Fonts: Jukebox Music
Bold, Studmuffin Burley-Boy from Font Mart

Brown Jordan shopping bag
Brown Jordan Company

Page 124
EDOX advertisement
Electronics For Imaging
Art Director/Designer: Laurie Gross,
Photographer: James Gross

Page 125
Monadnock Paper – IMAC
Pollard & Van de Water

Page 126
Pierre Garroudi advertisement
Schatz/Ornstein Studio
Photographer: Howard Schatz
© Schatz/Ornstein, 1999

Page 127
Olympic poster
Ted Wright Illustration & Design, Inc.
Art Director: Ross Neel, Designer/Illustrator:
Ted Wright, Client: Australian Olympic
Committee

Index